PENGUIN BOOKS

PLAYING TO THE GALLERY

'Brilliant . . . This book is full of good jokes, full of cartoons, full of memorable epigrams, but above all full of thought-provoking ideas that make you want to pause on every page and say: "Discuss". I have never read such a stimulating short guide to art. It should be issued as a set text in every school' Lynn Barber, *Sunday Times*

'Perry's tour de force is hugely entertaining. You could, genuinely, take an aphorism or a quote from every second page . . . This is splendid, transgressive stuff and a delight . . . in writing, he seeks to protect the personal in a deeply caustic art world, but in doing so also writes a love letter to art . . . a mischievous little hymn to 21st-century inclusivity' Melanie Reid, *The Times*

'Beautifully illustrated, it reveals Perry to be not just an artist but a wordsmith, too . . . This is writing with the eye of someone who says: "My job is to notice things that other people don't notice." It is full of insight, and of telling points . . . It is acute and funny at the same time. This, I think, is why people love Perry so much. He is really smart. He says the things we wish we had thought of, and asks the questions that we want to ask. What is art? How can we tell if what we are looking at is any good? Is it OK to like certain artists?' Sarah Crompton, *Daily Telegraph*

'Grayson Perry celebrates the joys of creation and exposes artistic pomposity in this polemic . . . A polemic for inclusivity . . . The great thing about Perry's statement of it here is that you are always convinced that he believes it and lives by it' Tim Adams, *Observer*

'With great good humour he debunks
distinctions between highbrow and low'
Michael Prodger, *Sunday Times*

'Reveals a more thoughtful side of himself . . .
an unpretentious aesthetic treatise'
Peter Conrad, *Observer*

'Perry's fun and wonderful book is a necessary
addition to a world that must continue to ask
difficult questions of art' *Publishers Weekly*

'He deftly analyses a lot of subtle, sophisticated
issues in a clear and readable fashion, throwing
in many fascinating observations and anecdotes
along the way' Carol Kino, *The New York Times*

ABOUT THE AUTHOR

Grayson Perry's first art prize was a large papier-mâché
head he awarded to himself as part of a performance art
project at college in 1980. Since then he has won many
other awards, including the Turner Prize in 2003. He is
now one of Britain's most celebrated artists and has had
major solo exhibitions all over the world. His 2013 BBC
Reith Lectures were the most popular lectures since the
series began.

GRAYSON PERRY

Playing to the Gallery

Helping contemporary art in its
struggle to be understood

PENGUIN BOOKS

PENGUIN BOOKS

UK | USA | Canada | Ireland | Australia
India | New Zealand | South Africa

Penguin Books is part of the Penguin Random House group of companies
whose addresses can be found at global.penguinrandomhouse.com.

First published by Particular Books 2014
Published in Penguin Books 2016
017

Copyright © Grayson Perry, 2014

The moral right of the author has been asserted

Printed and bound in Great Britain by Clays Ltd, Elcograf S.p.A.

A CIP catalogue record for this book is available from the British Library

ISBN: 978-0-141-97961-8

www.greenpenguin.co.uk

MIX
Paper from
responsible sources
FSC® C018179

Penguin Random House is committed to a
sustainable future for our business, our readers
and our planet. This book is made from Forest
Stewardship Council® certified paper.

Contents

How Much?!

IT WAS ORIGINALLY RADIO 4 IN THE FORM OF
The Archers, the BBC's middle-England soap opera
that has been running for over sixty years – not
known as a hotbed of the avant-garde – that actually
gave me the idea that contemporary art had now
become mainstream.

The watershed moment was when Lynda Snell,
a self-appointed cultural ambassador to Ambridge,
if you like, campaigned to try to get someone from
Ambridge on the Fourth Plinth in Trafalgar Square,

when Antony Gormley was doing his 'One and Other' project. And I thought, if Lynda Snell is a *fan* of contemporary art, then the game is won, or lost, depending on how you look at it. If a piece of participatory performance art can feature prominently in a hugely popular and socially conservative radio drama, contemporary art is no longer a little backwater cult. It is now a part of mainstream cultural life.

It's easy to feel insecure around art and its appreciation, as though we cannot enjoy certain artworks if we don't have a lot of academic and historical knowledge. But if there's one message that I want you to take away it's that anybody can enjoy art and anybody can have a life in the arts – even me! For even I, an Essex transvestite potter, have been let in by the art-world mafia.

I want to ask – and answer! – the basic questions that might come up when we enter an art gallery and that some people might think are almost too gauche to ask. But I don't! They might think they're irrelevant, or that they've all been answered now, or that everybody already knows the answer. But I don't think that's true. The art world needs people to keep asking it questions, and thinking about those questions helps the enjoyment and understanding of art. I firmly believe that anyone is eligible to enjoy art or become an artist – any oik, any prole, any citizen who has a vision that they want to share. There is no social qualification, no quarter of society you need to belong to. With practice, with

Artist Non-Artist Transuestie Potter

encouragement, with confidence, YOU can live a life in the arts. And this book offers up what I hope will be the basics of what you need in order to be able to do that. Though that is not to say it will be simple or that it will happen fast and in a convenient manner. Unlike shopping.

Very few people enter the art world to make money; most do it because they are driven to make art, or they love to look at it or be around artists. This means they are often passionate, curious, sensitive types. Nice fun people! The art world offers a nice life. Come in! It's not easy though, it's not all wealth and celebrity and free booze. A lot of man-hours and heartache are involved but it's a very rewarding and exciting place to hang out. Over the past twenty years or so a wider public is starting to realize this. I mean, take the Tate Modern. It's the first- or second-most visited tourist destination in Britain and the fourth-most popular museum in the world, with 5.3 million visitors a year. Contemporary art exhibitions across the globe from the Centro Cultural Banco in Rio to the Reina Sofía in Madrid to the Queensland Gallery of Modern Art in Brisbane regularly draw hundreds of thousands of art lovers. Art is very popular, and yet many of us are still quite insecure around going into galleries. I still find commercial galleries in particular quite intimidating. There are frighteningly chic gallery girls on the front desk, acres of expensive, polished concrete, a reverential hush around arcane lumps of

stuff, not to mention the language used around the art, which is often grandiloquently opaque.

For somebody to walk into a contemporary art gallery for the first time and expect to understand it straight away would be like me walking into a classical music concert, knowing nothing about classical music, and saying, 'Oh, it's all just noise.' We might be bemused or even angered by the work, but with a few of the right tools we might find that we understand and appreciate it. It can be tricky to get to the place where you can start to understand because, although you can intellectually engage with something quite quickly, to emotionally and spiritually engage takes quite a long time. You have to live with it. So bear that in mind.

I also hope that, as a practising artist confronted with a blank sheet of paper or a lump of clay and having to literally make the decision of 'What am I going to do?' on a day-to-day basis, my approach to the questions of contemporary art will be a little different from that of a commentator on the art world. I work on the coalface of culture. Though nowadays, of course, we live in an era when we're mainly a service economy, so perhaps really I should say that I work in the call centre of culture.

Also as a practitioner, and not necessarily an expert in the wider sense, I can use autobiography as analysis – something that is often seen as a sin by many academics. I am going to extrapolate from my own personal experience to wider generalizations

about the art world. And I hope that what follows
will be of interest not just to anyone who encounters
modern and contemporary art, but also to my fellow
artists, dabbing and chipping away in their studios.

Finally, what do I mean by the 'art world'? Well,
when I talk of the 'art world' I mean the culture
surrounding the Western model of fine art, artefacts
dealing with aesthetics or lack of them. I'm really
talking about visual art, but as we shall find out
later on not all of it is visual. I'm concerned with
the stuff you usually encounter in museums like
Tate Modern, or in commercial galleries all around
London and the rest of the developed world. You
may increasingly see this sort of art in collectors'

homes or in the street, in a hospital, on a round-
about, at a live event or even in cyberspace. I'm
also talking about the wider art world, its rituals and
people, best experienced at exhibition openings,
large commercial art fairs like Frieze in London or
Basel, and at biennales like the century-old one
held in Venice.

By intent or by chance the regular citizenry
increasingly come across the products of this often
arcane and mischievous subculture I call the art
world. As a tribal member of some thirty-five years'
standing, I wanted to reach out and attempt to
explain some of the values and practices that shape
something I love.

These are all reasons why I've called this
Playing to the Gallery and not, you may note,
Sucking up to an Academic Elite.

Democracy
Has Bad Taste

*What is quality, how might we judge it,
whose opinion counts, and does it even
matter any more?*

HISTORICALLY THE ART WORLD HAS BEEN
fairly inward-looking because it can operate as a
closed circle. In fact, I feel like the art world has a
pretty tense relationship with popularity. The circle
of artist, museum, critic, dealer and collector did
not necessarily need the good opinion of the public.
Now, I think that it's different, and that popularity
may affect the course of art history. Museums are
still (just about) the powerhouses of the art world
and they usually need visitor footfall to maintain

their public funding. Increasingly the artist who can draw the crowds gets a better seat in the pantheon.

Of course, there are still many artists who are very successful and who don't need the public at all. For them, the closed circle of the artist, the dealer and the collector does the job. You don't necessarily *need* the approval of a wider audience. An artist does not *need* the public to think his work is any good if they are not paying his wages or boosting his self-esteem. And this leads to the question of quality, which is one of the most burning issues around art: how do we tell if something is good? What are the criteria by which we judge art made today, and *who* tells us that it's good? That's perhaps even more important.

Now there's no easy answer for this one, I'm sorry to say. It's often thought important – in any line of work – to have definite, strong opinions and be a certainty freak. But many of the methods of judging are very problematic and many of the criteria that are used to assess art are conflicting. I mean, we have financial value, popularity, art-historical significance and aesthetic sophistication. And all these things could be at odds with each other.

If I look back, I really started thinking about the idea of quality in my second year at art college. At that time, 1980, it was almost de rigueur to have a dabble in performance art. Performance art being a live event often involving the artist as a

performer. It was a thing you had to do, a little bit of performance art to, you know, cover the basics.

So I did a little three-act performance. The first act was a chance for the audience to venerate me as a chastity-belt-wearing guru. The second was a lecture mocking the intellectual pretensions of some sections (Marxist) of the college and centred somewhat facetiously on the fact that 'art' was an anagram of 'rat'. The third act was the announcement of the results of an election that I had been running in the previous week or so, to elect the best artist and lecturer in college. I put up a little ballot box in college, it was all democratic, and of course this was a very facetious act and the

audience of course acted very facetiously in response and elected me as the best artist because they knew I was organizing it, and I won the prize, which was a big head that I'd made, a large papier-mâché carnival-style head. The first of many prizes in my glittering career.

I learned two things from doing that performance. One was to have very low expectations of audience participation, and the other one was that judging quality is a very tricky area. A lecturer said to me afterwards, 'It was entertaining, but I'm not sure it was good art.'

In organizing an election at college I was being mischievous as even then I realized that quality judgement was a complex business; being popular did not mean you were of good quality. In fact, within the art world, they often seem to be almost at odds with each other.

Take the most popular art exhibition in Britain and the fifth-most popular in the world in 2012: the David Hockney show at the Royal Academy. It was called 'A Bigger Picture', with those huge, joyful landscape paintings, and it was a paying show, people had to hand over money to go. Soon after it opened I was talking to a senior contemporary art gallery director (a free-to-enter, publicly funded institution, I should mention) and she said she thought the Hockney was one of the worst shows she'd ever seen. And I don't think she was alone. It's as though having such a popular exhibition

isn't to the taste of someone whose job it is to advance the taste of people in this country. So the large audience and its tastes are often a bane to those who wish to expand the field of what is thought of as good art by the public. There's a bit of a catch in that.

Now there were two very mischievous and funny Russian artists called Komar and Melamid in the middle of the 1990s. They took this whole idea of popularity literally and they commissioned polls in several different countries to find out what people wanted most in art. Then, when they'd got the results of these surveys (which were conducted by professional pollsters), they painted the paintings in accordance with the results. And the results were quite shocking. In nearly every country, all people really wanted was a landscape with a few figures around, animals in the foreground, mainly blue. It's quite depressing. After the experience they said, 'In looking for freedom, we found slavery.'

(The recent exhibition of L. S. Lowry at Tate Britain could be seen as a capitulation to popular uproar. Lowry has long been seen, probably mistakenly, as the poster boy of popular versus elitist taste in art and there was much complaining that his work was rarely hung. The Tate brought in respected, heavyweight art critics T. J. Clark and Anne Wagner to curate the show to add intellectual lustre to his popular appeal. Whether this will elevate Lowry's repetitive output to the credibility

level of, say, Rothko's repetitive output remains to be seen.)

So a visitor to an exhibition, like the Hockney exhibition, if they were judging the quality of the art, they might use a word like 'beauty'. Now if you use that kind of word in the art world, be very careful. There will be a sucking of teeth and a mournful shaking of heads because their hero artist, Marcel Duchamp (he of urinal fame), said 'aesthetic delectation is the danger to be avoided'. To judge a work on its aesthetic merit is to buy into some discredited, fusty hierarchy, tainted with sexism, racism, colonialism and class privilege. It's loaded, this idea of beauty, because where does our idea of beauty come from?

Proust said something to the effect that 'we only see beauty when we're looking through an ornate gold frame'. What he meant was that our idea of what is beautiful is entirely conditioned: things we regard as beautiful do not possess some innate quality of beauty, we have just become used to regarding something as beautiful through exposure and re-inforcement. Beauty is very much about familiarity, reinforcing an idea we have already. It's a constructed thing built up on shifting layers. We can make something a touch more beautiful just by the very act of exclaiming to a friend, 'Wow, that is beautiful!' Or when we go on holiday and all we really want to do is take the photograph that we've seen in the brochure.

You want to be on Machu Picchu on your own in perfect sunshine. Family, friends, education, nationality, race, religion and politics – all these things help shape our idea of beauty.

We may feel, like the critic Clement Greenberg, that 'You can no more choose whether to like a work of art or not than you can choose for sugar to taste sweet or lemons sour.' But unlike the taste buds on our tongue our aesthetic taste buds can change.

When we talk about the culture we consume it is often a dance around how we wish to be seen: what we enjoy reflects on who we are. I always cringe when I hear myself having a 'oh you must hear this' moment, when I want to share my current musical taste with a friend. He is obliged to listen to it and I fear rejection of my very soul. It is always safer to slag something off than eulogize it.

That worrying about what others will think about our aesthetic choices is a part of the self-consciousness that is in the DNA of modernism. By 'modernism' I mean the 100 years of art leading up to, say, the 1970s. A time when artists were questioning and worrying about what it was that they were doing; they weren't just being swept along by tradition or belief. Self-consciousness, though, is crippling for an artist. As a schoolboy, I liked Victorian narrative painting and since then I've had to go through all sorts of contortions to justify my liking of this. I like paintings by William Powell Frith, and George Elgar Hicks, and why do

I like them? Because they're very English, lovely craftsmanship, social history, good frocks.

And I went through all kinds of twists and turns to justify my liking of these as the years went by. Early on I was a re-adopter and I would say, 'Oh, they're modern in their own time' and 'I like them in an ironic way' and 'They're almost exotic now', and then I would say, 'Oh, they're unashamedly popular.' And then all of a sudden they *were* becoming popular again, in a fashionable, in-crowd kind of way. And I thought, 'Oh no, I've no longer got kooky taste. It'll just look like I'm jumping on the bandwagon, liking Victorian narrative painting.'

Or, when I was thirteen, I liked photorealist painting because I could easily appreciate its skill. I learned at art school that it was a bit naff. I rode this out and, after forty years looking at art, I still like photorealism by artists such as Richard Estes, but perhaps now for its lyrical qualities and only when framed in authenticity by 1960s art history.

I have made a study of taste and much of what I found can be applied to our taste in art. The difference might be that in the post-nineteenth-century art world it is by necessity a hideously more self-conscious process. Our job as artists or curators is discriminating, whether between colours and forms and materials, or ideas, artists and eras. When someone buys curtains they may go with the ones they 'like' but they do not necessarily interrogate themselves about what 'like' might mean.

But that sort of self-consciousness is a defining aspect of being an artist today, examining not just *what* to make and how, but what is this business called art? So you can see how difficult it is, the role of the artist.

As an artist, the ability to resist peer pressure, to trust one's own judgement, is vital, but it can be a lonely and anxiety-inducing procedure. In those discomfiting moments of uncertainty this is when the 'baloney generator' kicks in. This is what cognitive scientist Steven Pinker called the part of our mind that cannot stand not knowing, not understanding fully, so when confronted with a soft problem like 'What is good art?' our mind starts generating baloney to cover its discomfort.

This very unsettling, subjective nature of beauty has prompted people to look for a more empirical explanation of what we find aesthetically pleasing. This, I think, is folly. I like to quote the philosopher John Gray: 'If belief in human rationality were a scientific theory it long since would have been falsified and abandoned.'

In a recent set of studies the psychologist James Cutting demonstrated that merely exposing people to certain images means they form a preference for those same images. In a series of experiments using photographs of impressionist paintings he found his subjects preferred the ones they had been exposed to more regularly even compared

to very similar or even more famous images. His conclusion was that the more frequent broadcast of certain images via books, newspapers, magazines or television helps maintain what is seen as the canon in our culture. If we constantly see pictures by artists like Degas, Renoir or Monet in a context of high-cultural capital we cannot help but find them beautiful. Apparently.

It may not be that simple though. In another experiment psychologists showed works by the nineteenth-century master Millais next to work by hyper-popular but critically panned American kitsch painter Thomas Kincade. After repeated exposure the people in the study formed a measurable preference for the old masters. Maybe the experiment had found evidence that there might be innate formal qualities that we respond to in art. Maybe repeated exposure to good art makes us like it more and the opposite happens with bad art.

There are so many variables in such experiments that I remain a sceptic. Over the centuries many people have become attached to empirical explanations of what makes a great work of art. The ancient Greeks discovered the golden ratio, said to produce pleasing aesthetic harmony. William Hogarth, the painter, had his serpentine line of beauty, which he used to put into his paintings thinking this was a way of ensuring that each painting would be a beautiful thing. My favourite attempt at a recipe for a masterpiece is called the

'Venetian Secret'. Benjamin West, president of the Royal Academy of Arts in about 1796, was hoaxed by someone who said they had found the 'Venetian Secret'. This was a mythical thing that Titian and the Venetian painters of the Renaissance used: a formula for painting the ideal beautiful painting. Somebody brought this old letter to Benjamin West and he believed it was real, and he started painting paintings in this formula, hoping it would work, and he was mocked hideously in the press for doing it.

But I feel some sympathy with the guy. I did a bit of research myself and I have found the formula that guarantees success in the contemporary art world. It is:

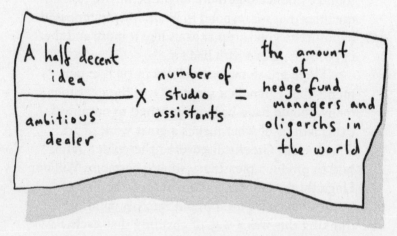

$$\frac{\text{A half decent idea}}{\text{ambitious dealer}} \times \begin{array}{c}\text{number of}\\ \text{studio}\\ \text{assistants}\end{array} = \begin{array}{c}\text{the amount}\\ \text{of}\\ \text{hedge fund}\\ \text{managers and}\\ \text{oligarchs in}\\ \text{the world}\end{array}$$

The Modern Venetian Secret

And there you have it, the ideal formula for art in the twenty-first century. Because of course the nearest thing we have to an empirical measure of art is the market. By this reckoning Cézanne's *Card Players* is the most beautiful, lovely painting in the world. I find it a little bit clunky kitsch but that's me. $260 million it's worth.

Monetary value is not what makes an artwork important of course but it often trumps all other meanings because people are easily impressed by huge sums of money. Much hoo-ha can be raised when a drawing – not even a painting – of Munch's *Scream* goes for $120 million.

Cynics may say that actually art is indeed now only an asset class, that it has lost its other roles, it's no longer about story-telling or mass communication or pushing boundaries. It's just big, lumpen loads of cash sitting on walls. And of course the opposite argument – it's art for art's sake – is a very idealist position to take because integrity does not pay the bills. Clement Greenberg, a famous art critic in the 1950s, said that art will always be tied to money by an umbilical cord of gold. So I'm fairly pragmatic about it. One of my favourite quotes is that you'll never have a good art career unless your work fits into the elevator of a New York apartment block.

And yet when a commercial gallery is setting up its show and it's pricing the art, it doesn't price works by quality, it usually prices the pieces by size. A big painting will cost more than a small

painting. I suppose there's a curious logic to that. It doesn't mean that the big painting is better. In my experience an artist's biggest work is very rarely their best. So at the secondary market, the auction, all this comes out in the wash and the good painting will always get the highest price even if it's a tiny little one.

There are other measures of quality that I find funny. Philip Hook, who works for Sotheby's, said red paintings will always sell best, followed by white, blue, yellow, green and black. But of course it's not just any old red painting that will make the highest prices. The very fact that an artwork has reached the auction block of a house like Sotheby's means it's by an artist who has already been validated.

This is a crux point when thinking about quality. Validation is the key point to understanding how some art is regarded as better than other art – at least within a large part of the art world, including most museums and galleries and roundabouts. The key to validation is to understand *who* is doing the validating, *who* is bestowing their good opinion, their money, their attention and time, *who* is giving value to certain artists and works of art. The cast of characters in this drama is large: artists, collectors, teachers, dealers, critics, curators, the media, oh, and even maybe the public.

What they form is this lovely consensus around what is good art. I did a pot once called *Lovely Consensus*. I asked my dealer for the top fifty names of

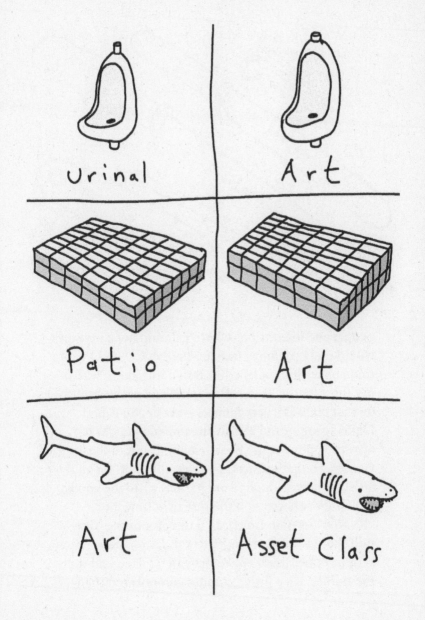

Urinal | Art

Patio | Art

Art | Asset Class

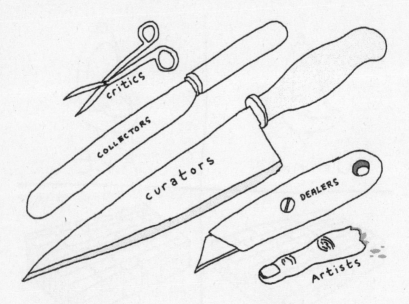

people and institutions where I should hope my work would end up, almost like the perfect CV, and I wrote them on to this pot in a decorative way and it was in my show for the Turner Prize, and one of the names on that pot was a very famous art collector called Dakis Joannou and he saw the pot and bought it over the phone while he was looking at it in the Tate Gallery. So that's just as an aside, a little tip for any artist. What you might want to do is write the names of famous collectors on the side of your work.

Now Sir Alan Bowness, a director of the Tate, said there were four stages to validation: peers; then serious critics; then collectors and dealers; and then the public. It's a little bit more complicated than

that nowadays. Of course it's still very important to be recognized. Validation from your peers is a lovely accolade to have. When I first started making pottery, my artist friends used to look at them and go, 'Pottery?!' And then they went, 'Yeah! Pottery, I get that. Yeah.' For quite a while I was 'an artist's artist', i.e., poor.

The days when a critic like Clement Greenberg could make or break artists are over. The good opinion of art writers is nice and every artist could probably quote their worst review word-perfect, but the press is now one of the multitude of voices in the art world.

Another member of that cast of validating characters is the collector. As an artist you always want the heavyweight collector to buy your work because it gives the work kudos. In the 1990s Charles Saatchi simply had to put his foot over the threshold of your exhibition and that was it. The media was agog and he would come in and hoover up all the pieces.

But of course being part of a prestigious collector's haul will not save mediocre work. On the flip side, collectors can also buy respectability with their art. Their wealth may come from dodgy sources, but buy blue-chip or difficult, culturally high-status art, and their image is polished just like the patrons of the past burnished their image paying for chapels in the grand cathedrals.

Art dealers, they're the next part of the chorus of validation.

A good art dealer can have a powerful effect on an artist's reputation just by association and inclusion in a reputable stable of talent. An emerging talent can benefit from showing at the same gallery as an established name. In 2012 I saw a show by yet-to-graduate Eddie Peake at the mega-gallery White Cube. He was showing alongside respected, mid-career Gary Hume and ageing modern master Chuck Close. The kudos can rub off in different ways: commercial galleries often find it hard to monetize artists who do very political performance art or mount vast installations or film a stomach-churning video. But the edgy cred of these artists can dilute the accusation that the gallery is just a glossy shop for mega branded goods.

The dealer also controls where your work may go, making sure works are 'placed' with respected collections. Public institutions are usually given a hefty discount because they are the preferred location for a work and they usually don't have as much money as the private sector. A good dealer will discreetly vet collectors and refuse to sell to those who are tacky (you don't want a tacky collector) or have a reputation for 'flipping' art. Flipping is buying a difficult-to-obtain work then reselling it at auction for a profit soon after. Dealers have a very powerful effect on the reputation of the artist in their placing of the work. This is a slightly mysterious process that many people don't quite understand: a dealer will choose where your work goes so it gains the brownie points, the buzz around it then

goes up. Collectors who are rejected, who perhaps don't have the brownie points to give out, can get quite annoyed.

Good dealers play a vital role in not just selling the works but promoting and contextualizing the artist. The major art fairs are nowadays a major arena for art, they've become a new validator, and they often prefer to include dealers who have an ongoing programme of exhibitions, who contribute to the validation process in an active way, and are not just, ahem, shops.

And then of course the next group of people we might think about in deciding what is good art is the public. Since the mid-1990s we've seen a lot more about contemporary artists in the papers and on the telly. Exposure of an artist in the media and the resulting fame is seen as tacky by many highbrow types; they don't think it should influence the validation process, they think being popular is a dodgy quality in art. But museums need visitor numbers, as visitor numbers are in a way another empirical measure of quality, and a well-known and popular name has increasing currency. The *Art Newspaper*, the periodical for those in the art business, publishes a special supplement every year dedicated only to visitor figures, such is their importance. If loads of people come to a show, that's a measurable fact, and of course it justifies their funding.

When I won the Turner Prize, having been cloistered in the art world for more than twenty years, I

Map of Museum based on Interior of Curator's head

'Radical' re-assessment of modern masters

Art we were given by a collector with truly awful taste

A dozen supremely good examples of famous stuff to give my institution an easy international reputation and also to sell merchandise in the gift shop

Drunken conversations at Biennales

'Vibrant' art that working class people might like

Undiscovered, preferably minority artists with dramatic back stories. (God please make them good)

Tiny Unrepresentative examples of hot artists' work that we can buy on our meagre public funds

Huge sculptures that get on telly and feature on travel websites

Ideas that sound like The Future

Why on earth did my predecessor buy this rubbish?

What I wrote my doctoral thesis about

was quite dismissive of the effect it'd have on my career. Ten years on I have changed my mind.

Today perhaps the greatest accolade you can give a work of art is to say it is of 'museum quality'. In another time the most powerful giver-outers of brownie points were the commissioners, who were literally the king, or the pope, and then the aristocrats and the generally wealthy. But today, at the top of the tree of the validation cast, it's probably the curators. Willi Bongard, a German art critic, called them the 'popes of art', and such is the power of the curators that they are bound by a code of ethics that says they mustn't themselves collect, buy for their own private collection, work which is in the field that they are overlooking in their professional life. Because they are then in a position of very great power. I mean, they could, if they bought a certain artist, then say, 'Oh, I think we should do a show of X at the museum.' And then, 'It's funny how the prices of X have gone up since the Tate Modern put that show on.'

I like to think the validation process is self-correcting to a certain extent. If the glitzy collectors are buying someone up and it's all shiny and lovely and the works are just being parked in arms dealers' houses, then the cool eye of academe will maybe go, 'Oh, I don't know about X now. This is getting a little bit cheesy.' And then if the academy is a bit too dry and heavy and it's all so bloody worthy, the work will a) go unsold, and b) go unvisited because probably in

all honesty it's a bit dull. And, of course, God help you if you're popular with the general public.

By each of these encounters the cast of valid-ators bestows upon the work and the artist a layer of patina that gradually builds into a reputation. All these hundreds of little conversations and reviews and series of good prices over time, these are the filters that pass a work of art through into the canon. The art that ends up, today, in a public gallery didn't get there by public vote. It's been through a series of juries – unofficial juries at private views and sales and fairs around the world – it's been given the right nods and the knowing winks. This consensus is very necessary as there aren't many people in the art world who have the confidence of a totally fresh good eye: people who can look at a work and see high quality in it with-out listening to the consensus or even reading the name on the label. And it can be very hard on artworks, the weight of that consensus. If you go to the Louvre and see the *Mona Lisa*, you're so built up because it's the most famous artwork in the world that it's inevitably going to disappoint. But if you just walked in on it, you'd go, 'Wow, that's an amazing painting.'

Of course, whether the reputation that's built up lasts or not is another matter. Francesco Bonami, who curated the Venice Biennale in 2003, described something he called 'Duane Hanson syndrome', after

the artist famous for his super-realistic figures. He said, 'I have this theory that some art – which is not a matter of importance in the moment that they're being done – but that some artworks accumulate dust, and some others, patina. So I think Duane Hanson accumulated a lot of dust. When you see sculptures that belong to a particular moment, they have been important, but now they are dusty. They have no patina.'

For the successful artist, eventually a consensus builds, hopefully one that is tested continuously in all different contexts. But what is the essence of this consensus? What is this patina that accumulates on art? In a way you want to boil down this lovely thing that all these people are bestowing on this artwork, this thing that anoints it with the quality that we all want. In many ways what it boils down to is seriousness. That's the most valued currency in the art world. When I won the Turner Prize, one of the press people, one of the first questions they asked me, was 'Grayson, are you a loveable character or are you a serious artist?'

I said, 'Can't I be both?' For all my jokes, as an artist what I desire is to be taken seriously. I have a horror of becoming trendily fashionable because then there's the inevitability of becoming unfashionable. Seriousness is different. One of the ways seriousness is bestowed and protected is through language. Ethnographer Sarah Thornton, in her book *Seven Days in the Art World*, quotes an

Art Forum editor (*Art Forum* being the magazine of record in the art world) saying that because a previous editor didn't have English as a first language, the magazine suffered from the wrong kind of unreadability during her tenure. But the art world is often scared of everyday clarity. Here's a paragraph from a wall text I copied down in the Venice Biennale in 2011:

> *A Common Ground* is based on the fact that affectivity remains a central access in contemporary Uruguayan artistic production. This exhibition puts forward two seemingly antithetical notions of this idea. On the one hand Magela Ferrero's personal diary, a written and visual work in progress, and on the other, the discourse and meta-discourse about language in Alejandro Cesarco's constant need to shed light on what it has said (and not said), multiplying the winks, quotes, repetitions and versions of his favourite subject matters.

Who knows what this means! Alix Rule, a sociologist, and David Levine, an artist, fed the texts of thousands of press releases for contemporary art shows in public institutions through a language-analysing program and they came up with a few observations about what they called 'International Art English'. 'International Art English rebukes ordinary English for its lack of nouns. Visual

becomes visuality. Global becomes globality. Potential becomes potentiality. And experience of course becomes experienceability.' They describe the metaphysical seasickness you get from reading this sort of text, where it all sounds a bit like inexpertly translated French.

Now this International Art English began in the 1960s in art criticism, it enhanced the authority of some writers to evaluate art and, as we have read, this is a precious capability to have. It became the language of seriousness; it bestowed a patina of complexity on artworks. It prompted a linguistic arms race, spreading like wildfire because everybody wanted to be thought of as being very serious about the art. It spread to institutions, commercial galleries, even students' dissertations. They all realized the power of this elite global language, and adopted it so they too might be worth listening to about things that are worth seeing. This is the language of a mobile, finger-on-the-pulse, international culture broker, what art historian and critic Sven Lütticken calls 'Highbrow Copywriting'.

The very impenetrability of IAE means that a non-fluent speaker might question their own judgements as not being educated enough. They might think you need to understand this in order to pass judgement. I just want to tell you now, you don't.

That feeling that we need to fully 'understand' an artwork before judging it is particularly strong when dealing with conceptual art, where a lot of the

works are little more than support systems or stage sets upon which prompts for ideas are played out. A judgement of the work on aesthetic grounds seems inappropriate. Conceptual art seemed a modest, self-effacing affair in the 1970s, consisting of typed sheets of text and small black-and-white photographs, things made of scrap wood, string and tape. The version we saw emerge in the 1990s seemed to have been run through an advertising agency (literally in some cases). It was sexier, funnier, bigger and – most important of all – more saleable.

In the 1960s pop art was *about* the idea of consumerism but it still looked like traditional art in some ways. Today a lot of the headline artists such

as Damien Hirst, Jeff Koons and Takashi Murakami
have developed a brand of art that is luxurious in its
finishes, accessible in its imagery, and mind-
boggling in its prices. These artworks *are* consumer
goods. These artists unashamedly embrace consum-
erism and employ large numbers of staff. Takashi
Murakami has over 100 assistants. He had a big show
at the Museum of Modern Art in Los Angeles and he
actually had a real Louis Vuitton shop in the gallery,
selling handbags, as part of the exhibition. He called
that his version of Duchamp's urinal, meaning that
by including an actual LV shop in the show he had
passed through a boundary like Duchamp did with
his fountain. He was saying, 'Yeah, I make stuff and
I flog it.' He was utterly unembarrassed about it.

(On the other hand, today there can be a
rejection of the creation of many works of art that
are not produced by the artist's hand. But the alter-
native is that things which *are* handmade could
become overly fetishized. I'm sometimes held up as
a poster boy of the handmade but I don't want to be
that person: we're in a new world now and people
can get too hung up on the idea of authenticity or
artisanal uniqueness, and the idea that they're
important ways to judge how good a work of art is.)

Unlike pop art that aped commercial products
with relatively humble art materials, Koons and co.
replicate the expensive materials and highly crafted
finishes of luxury goods. I find myself judging one
of his metal 'inflatable' sculptures like I would a car.

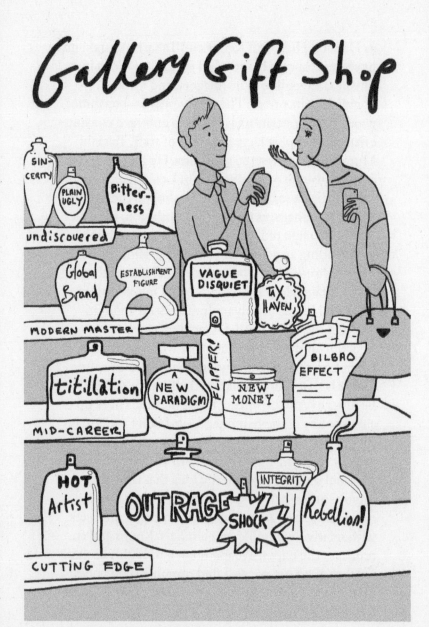

Ironically many of the new mega-rich collectors treat buying art in much the same way as buying a Ferrari or a handbag. Banks recognize the solid asset group that art is. They even have a little space put aside for it in their vaults. They will happily look after your silver, wine, art or gold; they have an acronym for it: SWAG.

It's easy to get swept up in the awe of scale and perfection of some contemporary art. And all this leads us back to the question of quality and what the criteria are by which we judge art made today. If an artist exhibits something indistinguishable from a manga figurine, do we judge it as art or product? I often play this game in an art gallery: which artwork would I take home with me? But is that a way of judging art, or is that just fantasy shopping?

Another type of art, also increasingly prevalent since the mid-1990s, which throws up even more questions as to how it should be assessed, is a type clunkily called 'relational aesthetics' or 'participatory art'. It's very difficult to actually judge it on terms of quality. To many people it wouldn't even seem like art at all. It might be some blind people in military uniform soliciting the crowd for sex. It might – these are real artworks – be illegal immigrants selling knock-off handbags in a gallery. Or it might be a pop-up Thai café. Maybe one of the best-known artworks of this kind is Jeremy Deller's *Battle of Orgreave*, where he restaged in 2001 the famous 1984 dispute, the miners' dispute,

using people from civil-war recreationists, the
Sealed Knot.

The whole idea of 'quality' seems to be about
a contested word now, as if you're buying into the
language of the elite by saying that something's
very good. One of the stars of participatory art is
Thomas Hirschhorn, whose sprawling work *Gramsci
Monument* involved building a temporary library,
workshop stage and lounge made of plywood in a
Bronx housing project in the summer of 2013. He
says, 'Quality-No! Energy-Yes!'

Which makes me wonder, whose energy are we
talking about? My experience of audience participa-
tion, as I wrote about earlier, is that it's unreliable
at best. And if quality smacks of elitism, what form
of art should the proles have? And if you make a
series of identical artworks that are churned out by a
technical process, hopefully they'll all be of as high
a quality as each other, won't they?

If these artists reject aesthetic judgement as
buying into the system, by what criteria should
we tell if they're good despite being energetic?
You might say, 'Oh, it's dull!' And they might say,
'Oh, you're just not understanding it with the right
terms.' Quite a lot of these works are politicized. So
are they as good as existing government arts policies
or social work? Do we judge them on how ethical
they are?

But then again I might as well say, what do
I judge them against? Do I judge them against

government policy? Do I judge them against reality TV, which does participation very well? For the art world, because so much of this art deliberately resists being commodified, it lacks the empirical validation of the market. It therefore depends more than ever on the validation of critics and institutions, who also often house and pay for these projects. And because contemporary art is being made now, most of it is rubbish. Without the market, much contemporary art is really left with popularity for validation. And, of course, we know (don't we?) what popularity leads to, because Democracy Has Bad Taste.

What I've attempted to explain is how the art that we see in museums and in galleries around the world ends up there, and how it ends up being seen as good. The art world can slightly frighten me because I'm quite middlebrow. The idea of good taste works within a tribe. The art-world tribe has its own set of values that aren't necessarily the same values as a more democratic, wider audience. But I think we come to art somehow accepting the system that got the art into the museum, or the gallery, or wherever. If the public chose the artwork that was in art galleries, would it be the same?

As Alan Bennett said when he was a trustee of the National Gallery, they should put a big sign up outside saying, 'You don't have to like it all.'

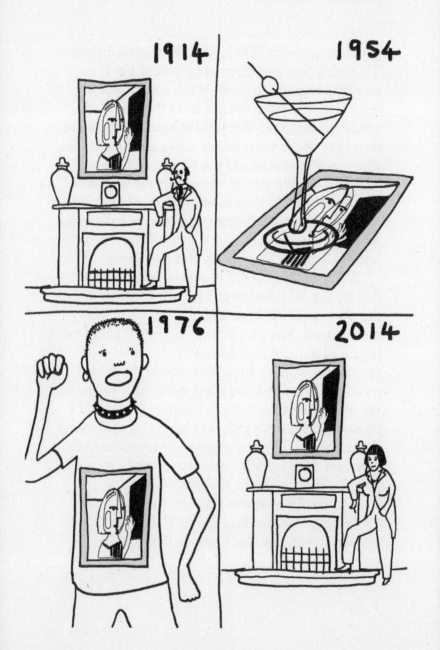

Beating the Bounds

What counts as art? Although we live in an era
when anything can be art, not everything qualifies.

A DESIRE TO MAKE THINGS AND EXPRESS ONESELF
can lead people to end up working in this strange
world of contemporary art. But once you're here,
what are you going to make? Asking the question
'What is art?' in the art world is to risk eye-rolling
and even hostility from the intellectually invested
sections of the art world.

The very idea of there being boundaries is
probably an anathema to many in the art world,
who like to think that to be an artist is to have

ultimate freedom. The artists of the past were locked into their time in history. Now we are in a time of post-historical art, anything can be art but not everything is art. In an age without boundaries I am more fascinated than ever by their possibility.

Dictionaries of art and artists often omit definitions of 'art' and 'artist'. I'm fairly sure I'm an artist and what I do is art but there are a lot of people and activities in my world that I don't feel so comfortable defining as such. I feel that often people want their practice to be defined as art because of the status (and often resultant economic benefit) that comes with that definition.

So to say that some things *can't* be art is quite a task. These days the boundaries are forever shifting. We're in a post-historical state of art; we're in a state where anything goes. But there are still boundaries about what can and cannot be art; the limits are just softer and fuzzier. I don't think these boundaries are formal – I truly believe anything can be art, I'm quite happy to engage with that intellectual idea. I think the boundaries now are sociological, tribal, philosophical and maybe even financial.

I was in a taxi going through west London once and at a particular junction the driver remarked that there had once been a terrible murder on that spot. The reason he knew that was because when he was learning 'The Knowledge' his instructor had given the class such highly charged snippets of information to associate with important reference points so

as to aid their memories. Memory and understanding are not purely intellectual processes. They are also very much emotional.

I introduce this idea of intellectual and emotional memory because there's some dissonance between an intellectual and an emotional understanding of the boundaries of what art can be. Understanding a new development can happen pretty instantaneously; taking on board a big change at an emotional level might take years or even generations.

I've called this chapter 'Beating the Bounds' after an ancient ritual that used to go on way back in Anglo-Saxon times, before the advent of accurate maps. When a parish wanted to make sure that everybody knew where the edge of their parish was, a group of old and young parishioners would walk the boundaries of the parish with a priest, to pass on the knowledge of where they lay. They would march round them in a very ceremonial way. And when they reached an important point or marker stone, they would beat the boys with a whip, to ensure they had a strong emotional memory of that exact location. Because that's how we remember things. Our emotional remembering is very powerful.

So I want to give you a few little stings of the whip, so that you might remember where the major boundary markers are as we trawl around the edge of the art world.

(Of course there's a subsidiary question that hangs in the air and I want you to hold this one in

the back of your mind as we walk the bounds: why would someone want anything they're doing to be considered art? I mean, there are quite a lot of reasons, the most obvious one being because they're an artist! 'It's what I do!' Or maybe they just want a good excuse to do something. There's a lot of 'I fancy doing that. Let's call it art.' And of course one of the strongest reasons why you'd want your activity to be called art is economic because there's an awful lot of money – $66 billion in 2013 – sloshing through the art market. That's quite a nice incentive to call what you do art.)

Ask a young child what 'art' is and they would probably reply 'drawing, painting and making sculptures' (unless of course it is a particularly smart-ass middle-class child from north London who'd probably say 'performance art' or something like that). Intellectually I understand this is a very narrow definition of art but emotionally I am still very attached to a child's idea of what art is. I grew up thinking that drawing, painting and making sculptures was art, and all the art I love is quite traditional. So even though I can intellectually engage and even appreciate some of the more expanding field of art, I still am more attached to the old thing.

That is, art as a visual medium, usually made by the artist's hand, which is a pleasure to make, to look at and to show others. For most of the history of art

this would have been a good, if rough, starting point for answering the question.

The Greeks didn't have a word for 'fine art' as we understand it. The Romans were snobbish about what constituted the honourable (liberal) arts, like rhetoric or music, and the dishonourable (sordid) arts, where they put sculpture and painting because they involved a lot of mess and hard labour.

The concept of 'fine art' is a fairly recent construct. We have put paintings on walls and made sculptures since prehistory but ring-fencing it as a special activity as we understand art (something having a privileged status that might be hanging in a museum or gallery) is relatively modern. The art historian Hans Belting thought that the idea of art as we understand it started around 1400.

This idea of art trawled along and was refined and we really took it for granted – oh yeah, that's art, that's art – until modernism came along in the mid- to late-nineteeth century. People started questioning what was art, what's this thing we're doing? And it went through this long transition, this very self-conscious process where people, artists, started questioning the nature of art until, in the 1910s, along came Duchamp, who famously posited that anything could be art.

But the traditional idea still lingers on. If you're on Google Maps and you put in 'object of interest: art gallery', the symbol that shows you where the art galleries are is a little black painter's palette.

In 2000 a group of art experts voted Marcel Duchamp the most influential artist of the twentieth century. What did he mean by art? His idea of the ready-made – that just by choosing something, a urinal or a bottle-drying rack, one could denote them art at a stroke – exploded the possibilities for artists. Now, in order to tell if something is a work of art or not, all that we need to know is that someone says it is. This seems to me quite an arrogant assertion. It is all very well for Marcel to say something is art but I'm sure a lot of people have disagreed passionately with him – even his fellow artists. His definition is dictatorial. I think for his idea to really work, other people, a working quorum, if you like, had to agree with him. This took some time.

When he decided that anything could be art he got a urinal and brought it into an art gallery. That we know about this is a freak of survival. The original urinal that he put into the independent art exhibition in New York in 1917 was destroyed soon after. It was lucky someone took a blurry photograph of it and that it was recorded, otherwise it would never have gone on to be this incredibly influential and important moment in art history. I find it quite arrogant, that idea of just pointing at something and saying, 'That's art.' It's a very intellectual idea of art somehow. And quite funny.

But now, nearly 100 years later, his influence and its emphasis on art as an intellectual pursuit have prompted other debates around the definition

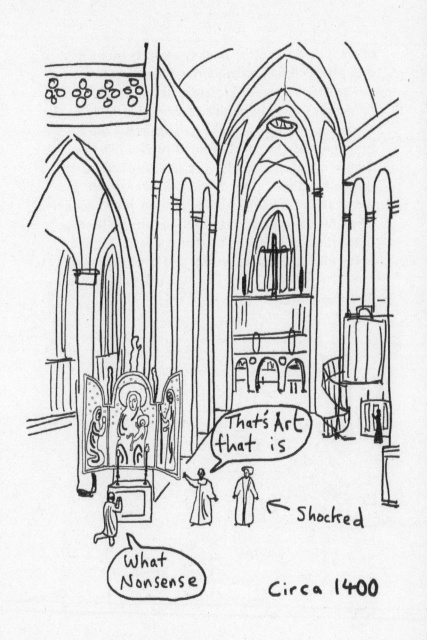

of art. The street artist Banksy recently brought into play a curious twist on this Duchampian power. One of his works that he'd put on the side of a north London Poundland shop of a child worker sewing Union Jacks – that was his contribution to the Queen's Diamond Jubilee celebrations – was subsequently very carefully hacked off the wall and put up for auction. Banksy declared the work was no longer a Banksy now it had been taken off the wall. Banksy used his artistic licence to redefine an object as not being his art. I'd like to be able to take this further and have the power to declare things I don't like as NOT being art. I'd love that power.

I like it when the power of the artist to declare
something a work of art is somehow challenged.
A group of schoolboys visiting Birmingham City
Museum and Art Gallery in 2000 ate what appeared
to be some sweets left on a shelf but which were in
fact an artwork by an artist called Graham Fagen.
But they were also sweets! The boys were right!
You can't deny that.

The poet W. H. Auden liked heavy blankets
when he was in bed. He liked a weighty bed. (He
wouldn't have liked duvets.) Once, he was in a house
and he didn't have enough blankets on his bed, so
he took a painting off the wall, still in the frame, and
laid it down on the bed. I love the idea that he took a
painting and made it functional.

Another way that art often stops being art a bit
is when it becomes incredibly famous. If you go and
see the *Mona Lisa*, it's like seeing a celebrity. People
just want to take their photograph in front of it. I
can hardly see it as art. And of course the other thing
that stops art almost seeming like art is when you
just look at it and think, 'Oh my God, that's worth
$250 million.'

This idea that Duchamp put forward – that
anything could be art that he decided was art –
people engaged with it intellectually, but it took
quite a long time for people to really get going
with it as an idea. The first half of the twentieth
century – all the isms: cubism, futurism, surrealism,
abstract expressionism – seemed on the whole to

concentrate on making formal and content innovations within traditional tangible media. The cubists may have exploded notions of representing space but they did it mainly with oil paintings. Art history was still mainly being thrashed out with brush on canvas fifty years later by the abstract expressionists. Artists being artists of course experimented wildly but it wasn't until the 1960s when Duchamp's idea really came to fruition, when it was taken up by the pop artists. In 1961 the artist Robert Rauschenberg was asked to paint a portrait of a gallerist called Iris Clert. And in response to this request, he just wrote a little telegram back to the person. He wrote, 'THIS IS A PORTRAIT OF IRIS CLERT IF I SAY SO.' And that was a work of art. But it's not quite the same as Duchamp's cool observer, because Rauschenberg claims the role of meaning maker for himself, the creator.

With Andy Warhol, one of the most interesting artworks he did was his Brillo boxes. He made some plywood boxes exactly the same size and shape as Brillo boxes and he stencilled the sides with the pattern of the logo of Brillo, so they looked to all intents and purposes exactly the same. But they weren't! They were art Brillo boxes. This was a moment when almost the whole idea of art collapsed; it was very tricky to tell the difference between the real Brillo box and the art Brillo box.

There's a nice little ironic twist to this story – the guy who designed the very attractive logo

for the Brillo boxes was an abstract expressionist painter. So he played a part in the downfall of his own art movement in many ways.

And since the 1960s, really, truly anything has been declared as an artwork. Piero Manzoni famously canned his own faeces and sold them by weight for the price of gold. He also made a piece called *The Base of the World* where he put a huge metal plinth in the middle of a field and turned it upside down, therefore rendering the entire globe as his artwork. Artists have made art of their own bodies and other people's, walking, sleeping, shooting themselves, getting sunburnt, the landscape, animals, light, film, video. Even pottery has been declared art.

So art has become this incredibly baggy idea.

When I think of the sort of bag that art might be, it's one of those very cheap dustbin liners – the ones that, when you drag them out of the dustbin and you're walking towards the front door, you're praying that all the rubbish won't spill out all over the hall carpet. That's what kind of bag art is. It's become this incredibly permeable, translucent, fuzzy bag.

A good example of this fuzziness for me was when Loyalist terrorist Michael Stone charged into the Northern Ireland Parliament in Stormont carrying a viable explosive device. Luckily he was arrested and stopped from blowing himself up or whatever. In court he tried to downplay his actions by saying that he had not intended to endanger life,

it was all a piece of performance art. I think it shows that art had become so associated with shock rather than beauty that it seemed a plausible defence for an act of terror.

This is a relatively common tactic in recent years, where someone declares whatever they fancied doing anyway as art to somehow lend it kudos. This concept was brilliantly parodied (or at least I hope it was a parody) in 1998 by a group of Leeds art students. They got a £1,000 grant for putting on their degree show at the end of their term at art school. And when it came to the exhibition, theirs consisted of a series of holiday snaps of

them on the Costa del Sol, frolicking on the beach, and some holiday souvenirs and the air tickets. And of course there was outrage and the papers got hold of it and it was front-page news: 'Art students spend grant on holiday and call it art.' I thought it was very funny. But then the real coup that these students pulled off was that they'd faked it. The money was still in the bank; the tan had come from a salon; the beach they were on was Skegness; the souvenirs had come from the charity shop and the tickets were fake. They brilliantly wrong-footed the media who held this common idea that if everything can be art, then art is this stupid mucking about, the idea that you can do something and then just call it art.

I think they got a First.

To frame something as art has become the get-out-of-jail-free card, a kind of bagsy and no returns to accusations of ineptitude.

When some people embark on doing something that they might fail massively at they call it an 'art project'. A tactic employed by actors like Jared Leto when describing his alt-rock band (serious) or writers like Caitlin Moran when referring to tiling the bathroom (facetious). 'Hey,' she says, 'you can never get *art* wrong.' This is funny but it saddens me that 'art project' is now a byword for useless, unskilled amateurism. You know that often someone who's not very good at making television programmes becomes a video artist, and someone who's not particularly good at writing hit songs becomes an art band.

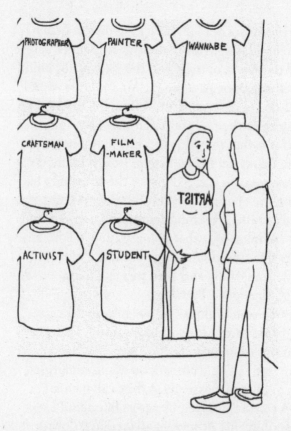

But I struggle with my curmudgeonliness here because intellectually I should be all-embracing and the art world should close ranks and we should all say, 'Yes, everything we do is really brilliant.' Thinking about what art is has meant I've had to question my own assumptions and prejudices along the way. I struggle with a vision of myself as an old fuddy-duddy, pre-twentieth-century arty type.

But, conversely, I'm coming to realize that in many ways I myself am a conceptual artist masquerading as a craftsman: I employ traditional media like pottery and tapestry and etching in a teasing, reactionary way. But I enjoy correcting people when they suggest that my dressing up in women's clothes is part of my art. Recently a video artist suggested that a series I'd done for TV was art. I replied, 'No, it's telly, I made it with telly values in mind.'

My own personal experience regarding definitions of art has revolved not so much around formal boundaries – for example, that art has to be something done by an artist – but around boundaries concerning taste. I think of it as a form of snobbery. Beneath the sophisticated tolerance – 'Yeah, everybody can make art and everything they do can be art' – there's an interesting kind of class snobbery. Some art is more equal than others. Like a urinal – bringing that into art, that's really radical. And a shark, bringing that into the gallery – oh my God, that's an amazing thing. But a pot, now that's craft.

I called an exhibition of mine *The Vanity of Small Differences*, after a phrase from Freud, 'the narcissism of small differences'. He noticed that the people that people hated the most were the ones who were almost the same as them. That's the thing about pottery and craft. It's too close to art.

It's also maybe the root of the worry about the middlebrow. Highbrow defenders of this trend for all-inclusiveness in the art world will often cite

middlebrowness as the sin of their opponents. Since 1960s pop art the art world has been happy for artists to use the lowbrow to add zest and authenticity to their works. But middlebrow has resonances of the suburban bourgeoisie who might see art as aspirational by association.

Perhaps a defining aspect of middlebrowness is its allegiance with the child's idea of what art is: painting and sculpture, or at least nothing too challenging. Middlebrow people like David Hockney or Jeff Koons, or at a pinch that bloke who did the big sun at Tate Modern. So perhaps there's a tension between the forward thinkers, wanting everything to be art, and people who want a more traditional definition of art.

If you think of contemporary art as the vibrant city centre of culture with all the young, happening, trendy things going on, and you think of the old masters as this beautiful mellow landscape in the distance, then craft is probably thought of as a suburb that you drive through on the way to your second home.

Cool, modern thinkers might say, 'Hey, relax, Grayson, why are you so uptight about things being defined as art?' Well, I need to know whether to put my art goggles on, whether I should think and feel about the work as an artwork, whether I can apply art values to it. The philosopher George Dickie said an artwork is 'a candidate for contemplation or appreciation'.

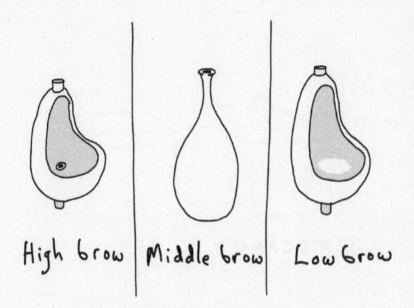

High brow | Middle brow | Low brow

When I was at college in the late 1970s one
of my fellow students, Jonathan Green, left the
definition to democracy. He made a metal box and
wrote on it the question 'Is this art?' Below this
were two buttons attached to counters marked 'yes'
and 'no'. So the audience could vote, and whether
it was art or not would depend on where it was and
who saw it. In some ways the perfect embodiment
of the whole problem, except that experts usually
have the final say and, on the whole, democracy is
quite conservative and looks for visual beauty
and aesthetics.

A more considered test as to whether some-
thing is art might be, is it in an art context? Is it

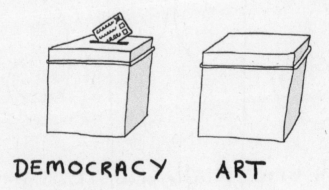

DEMOCRACY ART

in an exhibition, on a plinth? Arthur Danto, a
philosopher, said an artwork is about something,
has a point of view, a style, and it uses rhetorical
ellipsis – that is, it engages the audience to fill in
the gaps. The artwork isn't just there; you have to
respond to the artwork. But he also said that art
needs an art-historical context. This is an institu-
tional definition of art. The artwork needs to be in
the context where you might find art. After all, if
Duchamp had left his urinal attached to the wall
in the lavatory I doubt it would have had the same
impact. Of course this takes us back to the ques-
tion of who decides what counts as art that might
go into art galleries. If an artist has already declared

an object art, then by Duchamp's definition it must be art. But what if a curator or a critic chooses an object not made by an artist and places it in a gallery. Is it art then?

Curators have taken up the shamanistic power of the artist to turn other sorts of things into the valuable high-status art object. The fine-art gallery has been particularly prone to drawing in categories of object that have the look and feel of art and yet their headline definition (photography or video or possibly even pottery) lies in a different category.

But after all these thoughts and possible tests of what the boundaries of art are, I want to take you on my own beating of the bounds. And I have my whip here to remind you when we come to one of the important little markers as I trawl around. And I've got several little tests that I've devised, so you might know when you're looking at a work of art and not just at some old rubbish.

So the first marker post on my trawl around the boundaries is: is it in a gallery or an art context?

Now Duchamp's urinal, he could have left it plumbed in – but, no, he brought it into the gallery.

He went to a hardware place and he bought one and he brought it into the gallery and put it on a plinth.

Keith Tyson, a winner of the Turner Prize, did a piece once where he just got the things already in the gallery and made them into artworks with what he called his 'magical activation'. So he looked at the light switch and he called it 'the apocalyptic switch' and he looked at the light bulb and he called it 'the light bulb of awareness'. He was using his power as an artist to designate things art, but it was within the art context.

And this art context, it can be quite a powerful thing, but it can also be quite a lame excuse for an artwork. If I got the loveliest car in the world, a beautiful vintage Ferrari, and I put it into an art gallery and said, 'This is a work of art now,' it

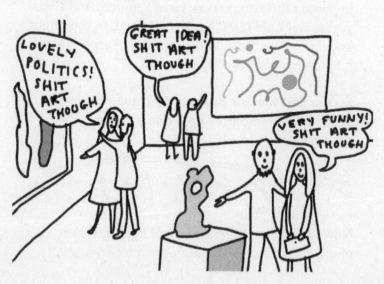

would be quite a lame work of art. It would be a lovely car, but quite a lame work of art. This happens a lot in the art world – it's what I call borrowed importance. You can go round an exhibition and say, 'Oh, I really like the politics. That's right on, those politics. That needs saying, those things. Rubbish art though.' Or 'That's really funny. Rubbish art though.' So the art-gallery context is a good test, but it's only a start.

My second boundary marker: is it a boring version of something else?

I call this one the opera joke phenomenon. When you go to the opera you go for the music and the colour and the costumes and the drama, and you get swept up in it all. You don't go for the jokes. Of course they have jokes in opera sometimes and everybody laughs uproariously, but they're really bad jokes. Sometimes I think that one of the things that defines something as art is that it's quite boring: it lacks entertainment value, it lacks pleasure. I mean, in the contemporary setting, one of the most insulting words you can use to describe an artwork is 'decorative'.

But it's a very noble thing to be decorative. And this idea that art is not pleasurable is wrong.

Leo Tolstoy said, 'In order correctly to define art, it is necessary first of all to cease to consider it as a means of pleasure and to consider it as one of the conditions of human life.' I don't think Leo went to a lot of video art, but he could be referring to having to stand for ages or sit on one of those tasteful but uncomfortable benches they always install in video-art rooms. Christian Marclay, a video artist, made this amazingly clever and brilliant piece called *The Clock*. It is a masterpiece of video art and I recommend it if you ever get to see it, but he did have sofas, which might have contributed to the good reviews.

The next boundary marker: is it made by an artist?

Art historian Ernst Gombrich said, 'There is no such thing as art, only artists.' So you have to be an artist to make art.

In 1995 Cornelia Parker, a conceptual artist, had a show at the Serpentine. Part of the display was a collaboration she did with the actress Tilda Swinton, where Tilda lay in this glass box. It was called *The Maybe* and Tilda was asleep and you could go along and look up her nostrils and stare at her very closely. It was an interesting thing and it was part of this exhibition. In 2013 Tilda Swinton

decided to do it again and so she put the glass box in the Museum of Modern Art in New York. We're in the age of Instagram and social media so this is a very big hoo-hah. I find this very interesting. I thought she was the artwork in 1995, but maybe she wasn't in 2013. But is she an artist? Was it different this time because it wasn't a collaboration with artist Cornelia Parker?

Another issue that boils up when we're talking about the question of 'Is it made by an artist?' is something like Aborigine art. I went to the 'Australia' show at the Royal Academy in London, which had quite a lot of Aboriginal art. They are very beautiful and powerful objects, but are they art? The old original bark paintings were spiritual maps and were about the people's relationship with the universe and the landscape. They're powerful items, but are they, and the paintings made more recently in the same spirit, contemporary art?

I read a story about this 81-year-old white artist in Australia called Elizabeth Durack. She painted Aborigine-style paintings under the pseudonym of Eddie Burrup and put them into an Aborigine art show, and there was outrage that she should borrow their special otherness – the fact that they *weren't* artists.

She was borrowing the power. And there was outrage at that but there wasn't outrage about the Aboriginal artists borrowing the power of being a contemporary artist. Can it be art if it's done by

someone who doesn't acknowledge themselves as an artist?

Next boundary marker: photography. Problematic.

In the 1990s every second show seemed to be photography, but how do you tell if a photograph is art? In the 1990s you could tell it was art photography because no one was smiling and they often had a stagey portentousness. But the main reason you could tell these photographs were art was that they were huge. Their size made them look more like paintings and less like snaps or photojournalism.

We live in an age when photography rains on us like sewage from above. So how do you tell if a photo's art? Well, you could probably still just see if they're smiling. If they're smiling, it's probably not art. And you could also ask, is there a lot of meaning emanating from this image?

I asked Martin Parr, the very famous and brilliant photographer, if he could give me a definition of an art photo as opposed to another kind of photo. And, almost in jest, he said, 'Well, if it's bigger than two metres and it's priced higher than five figures.'

And I thought, that's actually quite accurate if you think about it. Someone like Andreas Gursky,

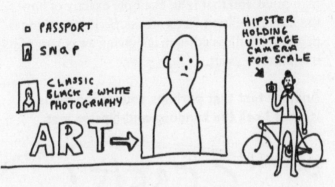

a famous photographer, makes these huge photographs, sometimes four metres by two metres, and his photograph of the Rhine has the highest price of any photograph ever: $4.5 million.

Now this brings us on to an interesting other boundary post, which can be applied to other artworks as well as photography, and that is the limited-edition test.

The reason that Gursky's photograph made $4.5 million is that it's an edition of five and the others were already in museum collections and so would never be available. This was the only one left on

the private market and that's why it made such a high price, and that is an example exactly of how the limited-edition factor works. So if something is part of an endless edition, it's giving away part of its qualification as art.

Another test that perhaps sounds facetious is what I call the handbag-and-hipster test.

Quite often you can't tell if something is a work of art apart from the fact that people are standing around it and looking at it. If there are lots of people with beards and glasses and single-speed bikes, or oligarchs' wives with great big handbags looking a bit perturbed and puzzled by what they're staring at, then it's probably art. People often say that art belongs to privileged people who've got a good education or a lot of money, and so if those people are staring at it, there's quite a high chance that it's art.

The other thing you might look for is a queue because people nowadays, they love queuing for art, especially participatory art – the art that kids can crawl around or you can take an Instagram of yourself in front of. There's a need for spectacle, public spectacle. I call that 'Theme Park plus Sudoku'. People want an outrageous and exciting

experience from art and then they want to slightly puzzle over what it's about.

This can take us back to participatory art and the construction of social experiences. If anything can be art then this sort of art cleans up the bits of life that have not already been claimed by art history. Tino Sehgal, nominated for the Turner Prize, sets up unsettling human interactions for people: children spouting fluent art speak, gallery attendants who engage you in philosophical debate, performers provoking the audience to talk about them. Tino is so dedicated to this dematerialized version of art that he won't even allow any photographs or recordings of his work.

Another artist often associated with this type of art is Liam Gillick, whose coloured Perspex constructions are 'potentially' meant to facilitate audience interaction. They often look like bits of architecture made for some event. Despite his titles often being a cool parody of management speak, *Arrival Rig* or *Dialogue Platform*, Gillick insists that the presence of an audience is an essential component of his art: 'My work is like the light in the fridge,' he says, 'it only works when there are people there to open the fridge door. Without people it's not art – it's something else – stuff in a room.'

But perhaps this is applicable to any art: if an artwork falls over in a forest, if nobody sees it, does it exist and is it an artwork?

I sometimes wonder if institutions and curators like to promote this type of art because there is less focus on the artist and their skill, so the cultural capital and status is picked up a lot more by the institution and curator who stage-managed the spectacle.

These works often bleed into theatre, dance, design, architecture, activism or running a café. In fact they are often indistinguishable from these other genres. The only way you can tell they are art is that there seems to be a preponderance of bewildered oligarchs' wives carrying enormous designer handbags present.

The next boundary post is the rubbish-dump test.

Another test for art was proposed by one of my tutors. He called it the rubbish-dump test. You should place the artwork being tested on to a rubbish dump and it only qualified if a passer-by spotted it and wondered why an artwork had been thrown away.

But of course many good artworks would fail this test because the rubbish dump itself might be the artwork.

In 1960 Jean Tinguely made a piece called *Homage to New York*, which was this big metal mechanical sculpture that self-destructed itself into

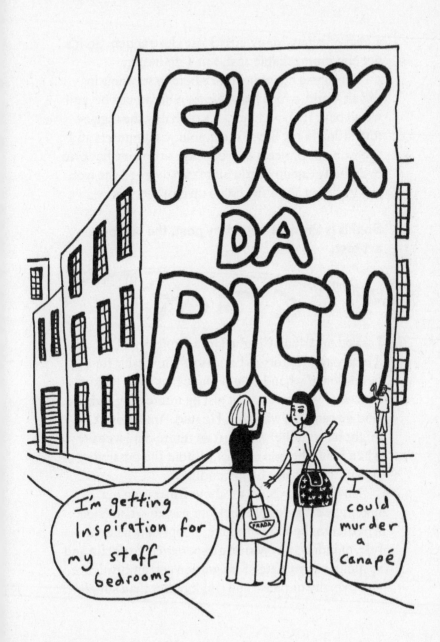

a load of scrap. Many artists use destruction. So it's not the most reliable test, but I do like it.

Of course one thing that's here to stay now in the art world, which has *exploded* what art can be, and we all have it in our lives – it's probably the biggest revolution in my life – is technology: computers and the web. Art projects are very easy to do now because everybody can do a little bit of creativity on the web and put their YouTube video up or whatever.

So this is the next boundary post, the computer-art test.

I asked my friend Charlie Gere, Professor of Media Theory and History at Lancaster University, for a definition of when I would know that I was looking at a piece of web art and not just an interesting website. And he came up with this. He said, 'You know it might be art rather than just an interesting website when it has the grip of porn without the possibility of consummation or a happy ending.'

In other words, it's all about frustrating our urgent need to double click our way to satisfaction whether in the form of a joke, an opinion, a fact, a sale, or indeed an onanistic experience, to detain and suspend us in a state of frustration and ambivalence, and to make us pause and think rather than simply

react. And in many ways that's quite a good definition of any artwork compared to any object.

Of course my tests aren't watertight, but if you put them all together in a Venn diagram, the bit in the middle is pretty well guaranteed to be contemporary art.

Picasso said, 'All children are artists. The problem is keeping them artists.' But of course there are loads of rubbish child artists. Their parents might have their work on the fridge, but really we all know that not all children are that good at art. But there is a truth in that comment, in that art is about relaxation and spontaneity and freedom.

One of the great enemies of the contemporary artist is self-consciousness. Ever since the definition of art started being challenged in the mid-nineteenth century, in order to work in the contemporary art world, an artist needs to be achingly aware of the audience and the history and the value and all the other things swishing about. So in many ways it would be lovely to be a child again, but you can't be an innocent in the art world. You have to address the self-consciousness and the rules of the art world and the history and the context in which you're working. An outsider artist, someone who doesn't think about these things, can be a fantastic maker of things, but they never have to deal with what it means to be an artist in the art world. Working out what it means to be an artist has been

almost the central concern of an artist since the nineteenth century.

I am haunted by this image: after a lecture once I had a student come up to me, who said, almost whimpering, 'How do you decide what to do your art about?' And I was struggling to say something and then I looked at her hand and saw she had an iPhone, and I said, 'Well, I didn't have one of those.' Because she has every image, access to all information, in her hand. When I started, I had none of that. It's a challenge for young people today, how to navigate the abundance of information and images.

But it's important to make art because perhaps the people that get the most out of art are the ones that make it. So I don't think it's important to be a good artist, no, unless you really want to be one and then it can be very painful if you aren't.

Perhaps there is a danger that art will just dissipate via the web and all of the amazing delivery systems we have now; that it will be so woven into ordinary life that art becomes some form of fallout, as though it has exploded and the dust has settled into every single piece of culture. Perhaps the web can bring into reality the idea that Joseph Beuys, the artist, had. He said everybody can be an artist, and maybe that's possible with the web. This is partly why I like the art-context definition of art. I want a fairly clear place that I can go to, where I can worship at the great temple of art.

Perhaps art is ultimately all about the personal experience, the reaction you have to it, the reaction I have to it; they won't be the same, but we are having a reaction. And the fact of it being physically there in front of me, something that, the minute you move away from it, is something else – I can appreciate the intellectual bag that holds all that stuff, but I'm still looking for the thing in the bag.

Although, of course, this idea that anything can now be art is the very essence of now, the mid-2010s. The way we think and feel and live now means in the future people will look back on all the variety of art and say, 'Oh, that's such a 2014 vintage!'

Because just as reputation changes over time, so too does the definition of what art is. And the boundaries of contemporary art are not formed by what art can be, but where, who or why.

I hope that my little stings of the whip will help you remember where the edges are when you're next in an art gallery.

(Of course the final irony – and I love this story – is that if you go to an art gallery and you see Duchamp's urinal sitting there – the artwork that started it all – it will have been handmade because the original was destroyed and, by the time people became interested in it, you couldn't get that model of urinal any more. And so those urinals were hand-made by a potter.)

Antiques Roadshow

Nice Rebellion,
Welcome in!

*Is art still capable of shocking us or
have we seen it all before?*

I WANT TO START BY TALKING ABOUT A FILM
I saw recently, called *Cave of Forgotten Dreams*, by
Werner Herzog. It's a marvellous film if anybody
wants to see it, all about the 30,000-year-old art in
the Chauvet Cave in the south of France that was
discovered fairly recently. I see it as a time capsule
of Ice Age art. It hadn't been opened for more than
20,000 years!

In the film, one of the archaeologists is looking
at one of the walls and it has these two overlapping

drawings – in charcoal – of horses. And she says,
'You know, these look like they could have been
done by a person on the same day. They're in the
same style. But when we carbon-dated these draw-
ings, they were 5,000 years apart.' And yet they
looked almost identical.

This is astounding; not just that these ancient
pictures survive alongside each other, but that art,
an activity so closely associated in our time with
innovation, could have remained stylistically similar
for five millennia. Now, artworks seem to go out of
date faster than a celebrity tattoo.

The world of art seems to be strongly associ-
ated with novelty. The mainstream media, with its
addiction to news values, seems particularly drawn
to the idea of there being an avant-garde. Work
is always 'cutting edge', artists are 'radical', shows
are 'mould-breaking', ideas are 'ground-breaking',
'game-changing', 'revolutionary', a 'new paradigm'
is forever being set.

And of course all artists nurture a tender dream
that they too are original. The worst thing you
can ever say – if you ever go to an art exhibition
and meet the artist at the opening or at a private
view or something like that – the worst thing you
can ever say to them is, 'Oh, your work, yeah, it
reminds me of . . .' Do not do this. This is a bad,
bad thing to do.

But I, and some other commentators in the art
world, think that we have reached the final state

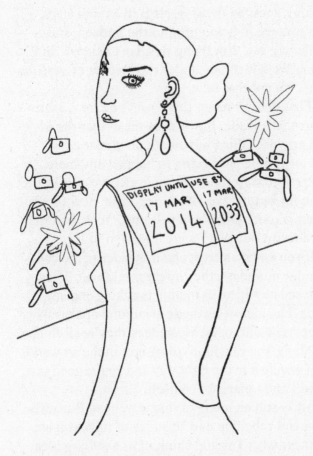

of art. Not an endgame, I don't mean it's all over. I mean we're in an ongoing state of omnidirectional experimentation. Anything can be art now. We're really agreed on that today. By about the mid-1960s, early 1970s, most things had at least been tried or suggested, and now we're in a state where

anything goes. So *formally*, art is in its end state. I can just see it, going off into the horizon, and people will say, 'I'm doing this. Isn't it new?' and I'll go, 'Well, it comes under the bracket of *anything*. So, no, it's not that new.'

That doesn't mean there won't be new, exciting art that's made. But it does mean that the idea of an artwork falling outside the boundaries of what art can be isn't going to happen any more. We know that freshness and novelty are part of the recipe for beauty. We like to see fresh, new things. But art is quite jaded today. It says, 'Yeah, had that idea already, but that's a great version of it.'

If you asked an artist about the idea of the cutting edge nowadays, they might giggle a bit. They might see new ideas as merely tweaking ongoing trends. The idea of aesthetic or cultural upheaval in art seems quaint today. Most ideas, they're all chugging along. You can do anything now in the art world, and if you do it in the right way and you're good at it, you will find a place for yourself.

Art is still an arena of inventiveness. But revolution and rebellion and this idea of upheaval are no longer what I would think of as a *defining* idea in art. A hundred years ago, art was almost synonymous with this idea of revolution. You'd go to the exhibition of modern art and people would be shocked and offended and the paintings would be called beasts. In 1905 an exhibition by a group of painters including Henri Matisse (now a coach-

party favourite) and André Derain was unfavour-
ably compared to a Renaissance-style sculpture
in the same room with the phrase 'Donatello au
milieu des fauves' ('Donatello among the beasts')
by the critic Louis Vauxcelles. The group was
thereafter forever known as the 'Fauves'. Grrrr.

But now we're a century on from that idea.
Robert Hughes, the much-respected art critic who
died fairly recently and whose death is lamented,
said way back in 1980, at the end of his landmark
television series *The Shock of the New*, 'The avant-
garde is now a period style.'

So I want to look at what's happened to that
idea and where it still sits in our culture. That
idea of the leading edge, the avant-garde, what's
happened to it? Because it still hovers in our
minds. And although art isn't necessarily the cru-
cible of all that is cutting edge in our culture any
more, it still is inventive, and maybe it does still
need to progress. Or is this progress happening but
it's dotted around the world and so we don't notice
it as strongly? What art world are we heading into?
Perhaps we'll have to adjust our idea of what a
cutting-edge artist looks like.

When I started at art college, revolution and
change and rebellion seemed fundamental to my
conception of art. I joked at the time that the main
thing I learned at college was to hate art. One of
Picasso's favourite expressions was 'We must *kill*

modern art.' That was how central rebellion was to the idea of being an artist. Parricide was encouraged. We had to establish ourselves in opposition to what had gone before. A young Robert Rauschenberg encapsulated this impulse when he took a drawing by reigning modern master Willem de Kooning and spent a month in 1953 carefully erasing it and then showed it as a piece of his own work. One of the delightful traits of the art world is that it enjoys being challenged. After a century, or even 150 years now of this idea of revolution and challenge, we still encourage it. A young outsider – talented, a little bit angry – comes along and goes, 'You, Establishment!' and shakes his fist at the Establishment and says, 'I am going to show you what fantastic innovation I have here!' And the art world looks down and goes, 'Oh, yeah, nice rebellion! Welcome in!'

There's even an acronym which suggests the kind of art that that young man or woman might be making, and it's MAYA: Most Advanced, Yet Acceptable. A term coined by 'the father of industrial design' Raymond Loewy when talking about the social constraints on what designs the consumer will accept.

But despite the laissez-faire attitude of the art world that anything goes, I think there are limits. The long tradition of increasing outrage (embraced in some 1960s art such as that of the Viennese actionists, which involved a lot of blood and nudity,

or American performance artist Chris Burden, who got someone to shoot him in the arm) was tested in 2003 when Chinese artist Zhu Yu was photographed eating parts of a stillborn baby. I don't think he quite got it; he thought shock was the real point of art. And people looked at the photographs and thought, 'Ooh, I think he's gone a bit far.'

But maybe he was calling the avant-garde's bluff and saying, 'I'll show you what shocking is!'

Or maybe the photographs he took just weren't very good.

In the case of my work the challenge might have been one of polite academic taste or fashion. Pottery was a naff, unfashionable medium practised by earnest folkies or dangly-earringed hippy ladies. In 1986 (around the time I started exhibiting) there was a TV advert for Babycham that summed up the process I was going through. (For those of you who don't know, Babycham was an early alcopop.) In the ad a gauche, posh young woman goes into a hip and happening bar and she orders a Babycham, a drink that then suffered from terminal uncoolness. On hearing her order the previously noisy crowd falls into stunned silence. The barman drops his cocktail shaker. Then the basso profundo of a real hip dude rings out: 'Hey! *I'd* love a Babycham!' and the whole bar erupts into desperate orders for the newly hip beverage.

So working in pottery was a mild rebellion. But really I see myself as the young woman, my first

dealer and collectors as the dude, and the rest of
the party as the wider art world. But in my case it
took a further fifteen years for them to want
a Babycham.

What I am trying to say is that *even* the wilfully
conservative position I took – making formally
conventional vases – was eventually welcomed in.

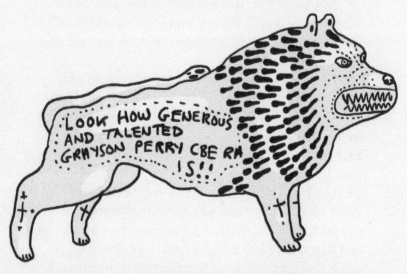

So now here I stand, a fully paid-up member
of the Establishment. But when I entered the art
world, the word that was constantly on people's lips
was 'post-modernism'. At that point in the early
1980s, modernism, with its confidence in ever-
mutating progress, was over. We were in a period
where anything went. And I for one felt cheated.
I wanted to plant my revolutionary flag and sign

up to a definite art movement, one that could go,
'Wooh, yeah, you're the old people who made rusty
metal sculptures. We're the *new* people who are
making *this* work.' I wanted to feel like those artists
did who staged the first New York Armory Show in
1913, America's first big encounter with the shock
of modern art. To signal that they wanted to make
a break from the past the emblem of the show was
an uprooted pine tree, an image borrowed from the
Massachusetts flag carried into battle during the
Revolutionary War.

I wanted to feel like many mid-century British
artists had when they encountered contemporary
American art, like Alen Jones in the early 1960s
when he first saw a work by Roy Lichtenstein, a
graphic painting of a leg opening a pedal bin. He
said it was a real culture shock. He said it was
amazingly liberating that this could be contempor-
ary art. And I wanted that experience; I wanted
that shock. I've never really had it.

After being brought up on the classic history
of art as a succession of isms, centred in different
cities, it all seemed to fragment. In the 1960s artists
had confronted all sorts of boundaries to what art
could be and each had given way without much
of a fight. So by the time I came along anything in
any style could be art. Art was no longer linked to
making nice objects or even objects at all, it was
a sub-branch of philosophy. Leaving college I felt
like one of those Japanese soldiers who had been

holed up in the jungle only to emerge and be told
that the war ended years ago.

But in many ways, I was labouring under a misap-
prehension because art history never was this smooth
succession of isms. If you think about Picasso, he
started his career in the 1890s, painted one of the
early icons of modernism, *Les Demoiselles d'Avignon*
in 1907, and was still working right up to his death
in 1973. He practically outlived modernism and he
had a go at most of the movements that were around
along the way. And that's just one artist.

So artists can – awkwardly – keep working
past the sell-by date of their style. The Tate Britain
recently rehung its collection of British art and now
it shows us art in pure chronological order. It shows
us that the art movements of modernism overlapped
for decades. In one room a 1909 painting by the High
Victorian artist Alma-Tadema (all marbly nudes in
fantasy history) hangs near a raw 1906 life study by
Walter Sickert, an artist who pioneered painting from
newspaper photos long before the pop artists. In the
1990 room we have an angsty impasto cityscape by
Leon Kossoff, a colourful geometric painting by the
long-established Bridget Riley, a wall of conceptually
rotting flowers by Anya Gallaccio and the seemingly
casual photography of Wolfgang Tillmans.

The idea that art moved cleanly on and there
was only ever one way to be a contemporary artist
seems to be the specialism of a few, mainly male,
Certainty Freaks. Certainty is a dodgy business.

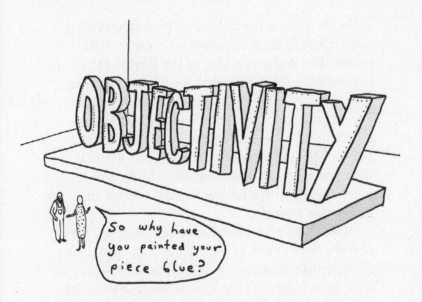

Of course these revolutions that went on in the twentieth century were to some extent a storm in a fur-lined teacup. They preoccupied the small village of the international art scene. For me, as an angry young man, there was something nice about working in a little-visited cultural backwater. A little kayak would occasionally come up with a critic in it, but just by being *involved* in the art world you felt edgy because the art world itself was this amazingly rarefied, difficult, dangerous place to be. And the rebelliousness wasn't just from the work or from the ideas that were floating about. It was also from the lifestyle of the artist.

Allan Kaprow, who established the idea of the performance-art 'happening' in the 1950s, and

probably qualified as a genuine bona fide cutting-edge figure in his time, wrote an essay in 1964 called 'The Artist as a Man of the World'. He posited (and this was probably quite an annoying idea to many people living in cold-water lofts in Soho at the time) that what artists wanted was a comfy middle-class life the same as most people. He thought the profession of artist was not that different from any other specialized job. And in many ways perhaps he was teasing, but it's an interesting thought.

Of course what's also happened since the 1960s is that a large chunk of society has embraced a lot of the artist's lifestyle. Virginia Nicholson (someone with great bohemian credentials because she's the niece of Virginia Woolf, a full-on bohemian) said, 'We're all bohemians now.' And if you think about it, all the things that were once seen as subversive and dangerous like tattoos and piercings and drugs and interracial sex and fetishism, all these things that artists made use of to show their freedom and otherness – they crop up on *X Factor* now on a Saturday night, for family viewing.

The last truly dangerous thing – the one thing you won't see – is underarm hair.

In some ways it's not that difficult to be subversive within art. The art world can be quite orthodox in some ways. One of the most rebellious acts done by an artist recently was by Tracey Emin. She supported the Tories.

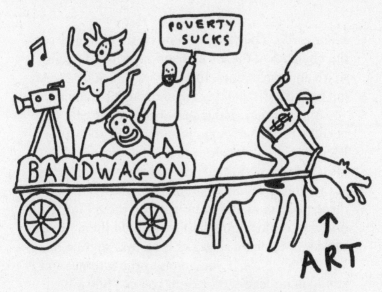

Creative rebels often like to think they offer an alternative to 'The Man', the capitalist system, like one of the Occupy protestors. But of course what they don't realize is that by being all inventive and creative they're actually playing into capitalism's hands because the lifeblood of capitalism is new ideas. Contemporary art is like an R&D department for capitalism. Karl Marx referred to this need for progress or novelty as 'the restless nature of capitalism'.

The art world is also a perfect model for neo-liberalism, when you think about the way it operates. Pioneers will come along to buy art hoping their investment will pay off because their taste will become a wider trend in society. That's just like any other investor – they're buying futures in the

avant-garde. They're gambling on the posterity of the object. And there's no fixed measure of quality, so it's amazingly fluid. In many ways, just by investing in it, they're making it more likely to happen.

And the outrageous gestures of the past become merchandise quite quickly. In 1960 Yves Klein, the French conceptual artist, did one of his most-famous performances – which was outrageous at the time – called *Anthropométries*, where he had these nude models and he painted them blue, with his famous blue paint, and he printed them on to canvasses to make artworks. This was quite a thing at the time. Now, if you go on to the internet and you look up loveisartkit.com, you can buy a kit which includes body paint and canvas and you, according to the strapline on the website, can make art while you make love.

So the radical art of the 1960s has become a messy-play lifestyle accessory for the *Fifty Shades of Grey* generation.

Maybe the biggest change in the past thirty years is that contemporary art is now huge. At the last count there were 220 art biennales around the world.

My nickname for the Tate Modern is the cult entertainment megastore. This comes from a shop that sells comics and film merchandise. The shop is called Forbidden Planet and underneath its sign it describes itself as 'the cult entertainment megastore'. This seems an oxymoron to me. If

something is cult I assume it only appeals to a few cognoscenti, like art used to. How could it support a megastore? Now, when I go to art galleries, I'm often very aware of their brand identities. I can feel like I'm having a branded aesthetic moment.

Some diehard avant-gardists get upset by how precious and commoditized previously counter-cultural throwaway art has become. In 1996 serial boundary trampler Brian Eno, the musician, was upset with the way these radical works had become normalized. So when he saw Duchamp's famous fountain, the urinal, on display in the Museum of Modern Art in New York he rigged himself up with a device involving plastic tubing and a little bag of urine and he urinated through a small gap in the display case and let the urine flow into Duchamp's fountain/urinal. Afterwards, when he was inter-viewed about it, he said, 'Since decommodification was one of the buzz words of the day, I described my action as re-commode-ification.

Whenever I hear artists moaning about the commodification of the art world and the way that art has just become this money-generating thing, I always think of this great sketch by the comedian Bill Hicks where he talks about marketing and he says, 'Anybody here from marketing or advertising?' And when they put their hands up, he goes, 'You, die! Kill yourself now! Suck on a tailpipe! You are the Devil's spawn! You spread evil in the world!' And then he voices out what their reaction might

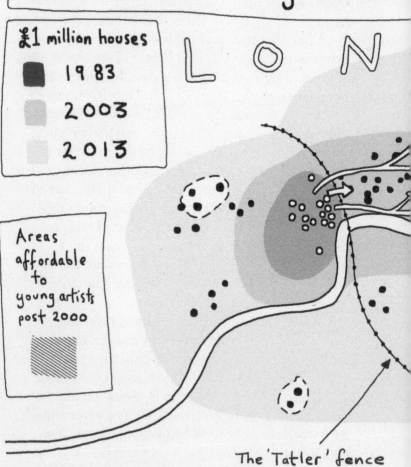

The Great Migration

£1 million houses
- 1983
- 2003
- 2013

L O N

Areas affordable to young artists post 2000

The 'Tatler' fence

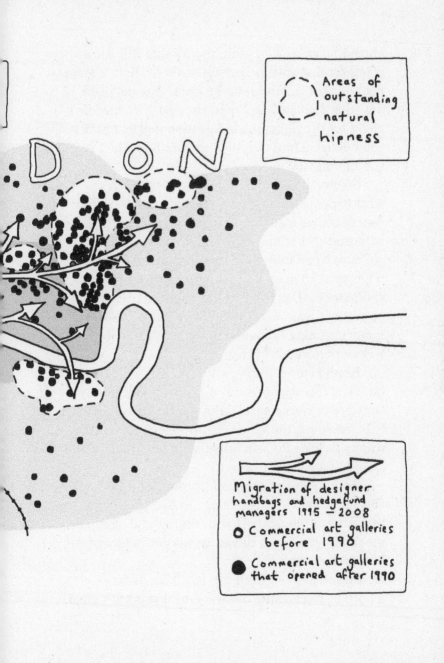

be and he goes, 'Oh, yeah, there's that Bill. He's going for that anti-marketing market. That's a great market, that is.' And then he goes, 'No, no, that's not what I mean!' And then they go, 'Oh, now he's going for the righteous-indignation dollar. That's a good dollar. They're young, they're hip. They've got a lot of free income.'

So outrage – and it's a perfect illustration of what happens – outrage has become domesticated. And of course many of these old avant-garde people bemoan this because they remember the chilly old days when they were running around in the nude covered in offal in some freezing warehouse, and now the Tate Modern has a special place to do performance art. They call it 'The Tanks'. Someone, rather cuttingly I thought, described it as a petting zoo for performance artists.

Keith Haring, the New York artist – sadly dead – he called this state of kind-of-giving-in-but-gently 'subversive compliance'. I think collectors often want to be anointed, the way Peggy Guggenheim said she was by Jackson Pollock urinating in her fireplace. But he didn't wee on the carpet.

Today, most of the world is pretty unshockable, and the art world is the same. So detached irony – this is a sad moment – has become the default mode of our time in the art world. And that can be problematic.

Here's a quote from the musician Tracey Thorn of Everything but the Girl. I think it's great.

It really describes the problem of irony. She says, 'It is difficult for people in the arts to be entirely sincere about things without looking like they have not thought about it properly. The problem with irony is that it assumes the position of being the end result, from having looked at it from both sides and having a very sophisticated take on everything. So the danger of eschewing irony is that you look as though you've not thought hard enough about it and that you're being a bit simplistic.' You see what I mean? That is the double bind you get yourself into when everything is ironic.

I have to protect myself against this because it's fine being terribly cynical and ironic when I'm out in the evening and I'm with my mates, but when I want to look at art, I want to have a sincere one-to-one experience with it because I am a serious artist. I've dedicated my life to it. So I go to exhibitions in the morning on my own when I can go, '*Hmm,*' and maybe have a little bit of a moment. I have to protect my tender parts from that wicked irony.

Perhaps the most shocking tactic that's left to artists these days is sincerity. And the shocks in the work are not formal but political or social.

I suspect that's why a lot of artists like politics – because it is real, it's serious, and they want to borrow that power because they know that we're not going to laugh at big, serious issues. And the arguments that you hear now in bars between artists, they're

not going to be about abstract expressionists versus surrealists, they're not going to be about video installationists versus giant photo peddlers. No, no, no. They're going to be between worthy activists and ironic market sell-outs.

In many ways, the great thing about being an artist is that you make your own career and so you choose what you want to do. It might be to make money. It might be to make a political point. It might be to be a challenging philosopher. There are myriad roles for the artist, not just one.

It was dangerous when art became synonymous with shock, which it did for a while in the 1990s. Then there was so much art that was seen as shocking that it became what people looked for when they went to an art show, when in fact art can be lots of different things. It can (between you and me) be beautiful.

I asked Cristina Ruiz of the *Art Newspaper* where she thought the cutting edge was. She said she had asked veteran curator Germano Celant this very same question at the Venice Biennale.

Celant said that, for him, art has to be dealing with some kind of crisis or sustained battle to be truly cutting edge. This could be anything ranging from an actual war to Aids (New York in the 1980s) or the battle for freedom of speech or equality (feminism, civil rights, and so on). He said that artists like Ai Weiwei and Shirin Neshat used to be

cutting edge but aren't any longer because 'they have the power of the West behind them'.

There is definitely a feeling in the art world that being a Westerner might be a bit of a handicap to credibility in the fashion for politically charged productions. Modern-art histories from Africa, South America and Asia are enthusiastically being introduced to us. Whether we are equipped to appreciate them is another matter: they are being made by people with different histories, traditions and values, and what looks formally familiar to us may mean something completely different in their culture.

But this idea of being real – of having integrity, sincerity, authenticity – these are qualities that all artists need to make their work; and they should protect them.

Of course, these qualities are also very, very valuable in the marketplace. Boho lefty arty-fartyness still has a high currency in the urban ecology. I have watched it happen several times in different areas. Artists are like the shock troops of gentrification. We march in. We're the first people to go, 'We like this old warehouse, yeah, we need a cheap studio.' Artists move into the cheap housing and the cheap spaces and they do their work and they're quite cool and a little bit of a buzz starts up. And then maybe a little café opens up and people start saying, 'Ooh, that's interesting, that area where those artists hang out. I'm going to go down there.' And maybe some designers open up a little

boutique and bask in the bohemian glow, and rents begin to rise and suddenly, before you know it, the dead hand of the developer is noticing. And then bang goes the area.

Developers should pay artists to live somewhere for ten years rent-free. We are a very precious commodity. Or society should ensure that there is a plentiful number of cheap places for people, including artists, to live and work.

Now this process of gentrification can come about in some interesting ways. There's a very wealthy mining magnate in Brazil called Bernardo Paz who has built up a vast 5,000-acre sculpture park called Inhotim – in the Brazilian jungle. He's asked artists to put big, ambitious works that are often too large for conventional institutions in this dramatic landscape. He's now building hotels, so rich tourists and guests can come and see these works. This is gentrification on steroids. He's avoided that awkward, urban-decay-hipster part of the cycle. He's gone straight from jungle to gentrification.

Another related trend is the re-privatization of the art world. Broadcaster Philip Dodd recently irked an audience by suggesting that the commercial mega-brand gallery White Cube was more important globally than Tate Britain. Public art institutions don't have as much money and often depend on individual or corporate sponsorship or financial support from commercial galleries. These connections can lead to a tangled web of conflicted interests.

In the 'experience economy' art helps big business 'render authenticity'. In return for big-buck sponsorship, corporations want a little of the commodified discontent of the art, the dangerous glamour of creative geniuses, to feed into their identity in the marketplace. When we talk of character and identity I often think we are talking of things that don't work or don't fit. Maybe companies want a veneer of intuitive, irrational, useless art to glue on their ruthlessly efficient business model.

As Andy Warhol put it, 'Some company recently was interested in buying my "aura".'

A public relations man with the American company Mobil Oil put it more aggressively: 'These programmes make us sufficiently acceptable so that when important issues are at stake, we can afford to be brutal.' That the company can be brutal towards artists and museums became evident in 1984 when it threatened the Tate Gallery, which it was sponsoring, with court action because it had put on an exhibition of works by the New York artist Hans Haacke, some of which take a critical view of Mobil Oil's corporate policies.

Fear of offending the sponsor can lead to institutions and even artists practising self-censorship.

Artist Nam June Paik said, 'Every artist should bite the hand that feeds him . . . but not too hard.'

Nam June Paik was a video-art pioneer. And another place where we find the cutting edge and innovation

is technology. Painting was revolutionized in 1841 with John G. Rand's invention of the paint tube. Suddenly painting was more accessible and could be done away from the studio, where previously pigments and oils had to be laboriously ground and mixed. Painting in fresh air – that was a revolution.

Around the same time photography was mounting a philosophical challenge to painting. What is art now that photography can do it? These two developments played a big part in kicking off Impressionism and the whole subsequent questioning of what art was – or is.

Despite being a poster boy of the handmade, like many contemporary artists my default mode of working is with 'new media'. I have embraced digital technology. I draw on Photoshop and my tapestries are woven in a matter of hours on computer-controlled looms. The technology enables me to design and make things I never would have attempted before.

But now we tend to be using technologies invented by other people. In the past artists were the real innovators of technology. And often they had quite prophetic interventions. If you go back to 1980 – that's a long time ago in computer land – there were two artists called Kit Galloway and Sherrie Rabinowitz and they created a work called *Hole in Space*. They set up a video screen in Lincoln Center in New York and another video

screen in Century City in Los Angeles with a live satellite link between them so that people could see and talk to each other in the other location. It was an unannounced event and the public's reaction was ecstatic and spontaneous – you can see it if you put 'hole in space' into YouTube – they're incredibly enthusiastic about it. The artists called it a public communication sculpture. In a way everyone involved was witnessing the grandmother of Skype!

Of course the danger of using hi-tech in art is that nothing dates like the future. I call these 'eight-track moments'. If a work depends too much on the novelty of technique then when the technology becomes commonplace the images are left naked. I find myself looking at the complex photo pieces of Gilbert and George very differently after the ubiquity of Photoshop.

I hear museums sometimes have stores full of redundant technology like video recorders, TVs and projectors, to use when 1980s video monitors go phut and the pieces can't be viewed any more. Technology moves in unpredictable ways. Dan Flavin, the American artist who made works using light and fluorescent tubes that he just bought from the hardware store – they have to hand-make some of those tubes now.

So art now follows technology rather than leading it; art is struggling to keep up. In many ways technology is more cutting edge than art.

Of course there are artists that work digitally in a very interesting way. Two artists, British artists – Jon Thomson and Alison Craighead – make thought-provoking, lyrical and often hilarious interventions and adaptations of the material flooding around the web. But I think they know they can't compete for impact with the majesty of Google Earth or the thrust and parry of Twitter.

The web does have the alarming potential to realize Joseph Beuys's prophecy that everyone is an artist. This could spell the end of art as we know it when everyone becomes a producer and we all drown in a sea of mediocrity made up of billions

of minutely niched micro-channels. The arbiters of taste melt away.

But in some ways this is an endorsement of art, in that the *approach* of the artist is more and more relevant in the age of creative capital. Art will change but there will always be artists. But perhaps the culture that changes our lives and shocks us will not be self-contained within the contemporary art world.

The culture that will have a revolutionary, disruptive effect on all our lives – that will change how we think and operate in the world – is not happening to a large extent, and certainly not exclusively, in contemporary art. It is probably happening in multiple locations, in some teenage bedroom in South Korea or some games designers' brainstorming session in California. Because if Michelangelo was around today, he wouldn't be painting ceilings. He'd be making CGI movies or developing 3D printing.

But I was thinking about what the ism of today would be, if this twentieth-century parade of modernism was in some ways the age of manifestos, with many of these art movements figuratively nailing their manifesto to the door of the art gallery. Perhaps the twenty-first century is the age of *plural*ism. We haven't said, 'It's going to be all about dreams now,' or 'It's all going to be about splodgy paint.'

And then there's another ism that crops up a lot in the art world today, and that is *global*ism,

because the art world now is a series of art worlds all over the globe, lots of different countries, lots of emerging world scenes. Or of course one of the big, dominant, squatting, toad-like things over the whole art world is *commercial*ism. That's a very powerful art movement that's going on. And then there's always that good old favourite, that one that always has enormous power: *nepot*ism.

I don't believe there is an avant-garde any more. There are just multiple sites all over the world at different levels, in different places, using different media for experimentation, and we live in this globalized, pluralistic art world with a lot of money sloshing around in it, and it's as varied as we are. Most of it is rubbish, but that was ever thus, and some of it is absolutely amazing.

But if we *are* at the final state of art then I'd like to end on a positive note and quote the philosopher of art Arthur C. Danto. He said, 'If the age of manifestos had a political parallel in ethnic cleansing, then in the age of pluralism we have a model of tolerant multi-culturalism.'

Wouldn't it be wonderful to believe that the pluralistic art world of the historical present was a harbinger for a political thing to come?

Some people may find it surprising, discordant even, that I end this chapter full of teasing with such a sincere, nay even earnest, quote, an anathema surely for any self-respecting British cynic. I feel this is a good point to revisit the question fired at

me a few moments after winning the Turner Prize:
'Are you a loveable character or are you a serious
artist?' Humour and mischief are a huge part of
my life but to stick at being an artist for decades,
through thick and thin, needs considerably more
motivation than just having a laugh. It is these more
solemn and tender sensibilities that I wish to speak
of in the next chapter.

I Found Myself in the Art World

How do you become a contemporary artist?

THE BASIC QUESTION I WANT TO ASK IS, HOW does someone become a contemporary artist? I could answer, 'Well, you just say you are one and start doing something,' but I think it's more complex than that. I'm going to focus on the experience of becoming an artist and of 'finding myself' in the psychological sense, that of self-realization. And also, like Dorothy in *The Wizard of Oz*, I found myself in this strange and often wonderful place,

'the art world', and that's the other meaning of this chapter title.

People like the idea that artists are somehow mythological creatures that spring fully formed from the womb, genetically gifted and filled with an urge that's there from birth. Another view is the one of Picasso, that every child is an artist. I take from this the idea that a child has an unselfconscious joy in creativity that is often lost as we get older. We're playing and painting and making things without a thought in the world and then as we get older we become aware of art history and that what we're doing might not be very good and so making things becomes harder and harder and harder.

I don't want to add to the cliché of the suffering artist in his garret, but I do feel that there is another aspect of childhood that often profoundly shapes us as artists. The human being, the human mind, has a miraculous ability to transform the traumatic experiences of its life into a positive. This amazing survival mechanism can often translate the most harrowing brutalities into masterpieces that speak to us all.

The clinical neuroscientist Raymond Tallis said, 'Art is expressing one's universal wound – the wound of living a finite life of incomplete meanings.' I like this idea that it's quite a noble journey we're on.

Of course not every artist has been shaped by a terrible upbringing. I understand there are many artists – though I've not met that many of them –

who are happy and who haven't got this traumatic thing in their past that they feed on. But I think most artists could cite a crux event in their past, a central motif of some time in their early life, which they can self-mythologize about why they became an artist.

Perhaps the most famous example of this is Joseph Beuys, a German artist in the mid-twentieth century. He was a gunner on a Stuka dive-bomber on the Eastern Front in World War Two and he was shot down over the Crimea. He says they crashed and he was thrown from the wreckage and was later pulled from the snow by some Tatar tribesmen who covered his broken body in fat and wrapped him in felt blankets to keep him warm, and they kept him alive until they could get him to hospital. And this is the reason, Joseph Beuys says, why he uses fat and felt in his sculptures – they're his signature materials – and also for his deep interest in shamanism, which was the Tatars' religion.

My signature material is clay, so my personal artist narrative starts when I made my first pot as a nine-year-old at school. I'd probably been a little bit naughty in class and I was put with the girls – you can see where this is going – and to make pottery I had to wear a PVC smock buttoned up the back with snappers. Mine was a little bit tight and it was light blue and very shiny, and they had a very pretty teaching assistant who snapped it on to me. And I can remember feeling quite turned

on by this whole scenario and I made my first primitive ceramic in this heightened state. Whatever sensitivities were fired off in unison that afternoon in 1969, perhaps they formed early pathways along which my subsequent art career would follow.

Now I don't want to overdetermine anything from this – why I went on to make pottery that often had sexual imagery on it – by making out there is some literal link from my childhood experience to the form of my art. Or maybe I'm doing what Joseph Beuys did, which is to twist the truth quite a lot to mythologize his own past to fit in with his later artwork, because the story he tells isn't quite how it happened. Apparently he did crash, but no Tatar tribesmen, or fat, or felt, were involved in his rescue. My story, though, is true.

But when you're growing up, art is certainly serious play. When I was a child I had a big, elaborate fantasy world – where my teddy bear was the king – which acted as a place I could escape to. It was very seriously crafted and it was a place I could go and survive during frightening times in my childhood.

Indeed, one of the most serious purposes that art, like play, can have is helping children deal with the difficulties in their lives.

In 2013 I visited a marvellous charity called The Art Room that offers severely troubled schoolchildren a beautifully equipped and staffed art

room as a refuge where they might catch a glimpse into their own creative power; where they might be reflective and not tossed about by the chaos of their lives. The teachers are also trained counsellors who help them, and together the room and the teachers and the making of art provide a safe haven.

I loved The Art Room because it seemed to formalize my own experience of the therapeutic benefits of making art. I was very moved by their pragmatic approach. They encourage the children to make solid artefacts that won't be thrown away, unlike the drawing that ends up tacked to the fridge at home. They would find some old furniture and ask the children to decorate it and then take that home. When a child takes a decorated stool or lampshade back to a home that has little furniture and bare light bulbs it must give them a sense of empowerment, that in a small way they have begun to change the world. Because of course art's primary role is not as an asset class and it's not necessarily about being an urban-regeneration catalyst. Its most important role is to make meaning.

For the young, that's quite a subtle process. While they're making art, the meaning of their art and the message they're sending, and the feel- ings they're expressing, they're all sneaking out under the radar. I'm sure my art teacher saw my unconscious leaking like some sort of stain on to my paintings when he suggested I might do well at art school. He noticed I was giving away more of

myself than my embarrassed, teenage grasp on self-expression would allow in language.

Art is not some fun add-on to life. Go back to the Ice Age and the artists then were still making art even when living constantly under threat from starvation, cold and predators. They set aside hours and hours and hours to make art. The need to express oneself runs very, very deep. The problem is often accessing this need, this primitive creative urge that we all have, without the self-consciousness that so curses teenagers and the art world alike.

One group of artists who perhaps don't suffer from self-consciousness as much as others is outsider artists. Since I was a teenager, I've loved outsider art. Outsider art is art done by people who haven't been to art school and probably don't have much knowledge about the art world or the market. They are artists who spontaneously create work, usually just for themselves, with little reference to art history or awareness of what else is being made today. And, of course, with little self-consciousness. Maybe they're not even doing it for other people; they just do it for themselves and never show anybody.

One of the most famous outsider artists was Henry Darger, who lived from 1892 to 1973. After a terribly traumatic childhood he found work as a janitor in a Chicago hospital. For the rest of his life

he laboured away in his spare time on hundreds of
large drawings and collages some ten feet or more
long in his small rented apartment, never showing
them to anyone. They only came to light after his
death. He wrote a 19,000-page novel called *In the
Realms of the Unreal* for which these paintings were
the illustrations. They depict a fantasy world riven
with conflict, child cruelty and stormy weather
where Darger could play out the injustices and
traumas of his own early years. There were seven
princesses and a complex story of child slavery and
the American Civil War is all woven in along with
Catholicism. He was fascinated by storms. Once the
novel and the paintings were discovered, research-
ers found that he was so driven to create that he
spent most of his money, his meagre income as
a janitor, on having magazine illustrations photo-
graphically enlarged so he could trace them on to
his works using carbon paper, because he didn't
think that he could draw.

I find this fantastically moving: that in the pre-
Photoshop age he had to go through this elaborate
process because he didn't think he was good at
drawing. His paintings are now selling for hundreds
of thousands of dollars, something he didn't live to
see. But I like to think art did give him one thing.
I like to think it gave him an incredibly rich life.

I decided to become an artist at about the age
of sixteen when my art teacher saw my buried
emotions poking through the surface of my artwork.

I noted my decision – 'I will be an artist' – on an imaginary piece of paper and I tucked it under my imaginary mattress and I've never really fetched it out again to re-examine it.

But ironically, at almost exactly the same time as I made that decision to become an artist, I lost my ability to play. I can remember almost to the day: I found myself alone with a box of my brother's toy cars, and usually I used to lose myself for hours narrating car races and dogfights under my breath. But that day I picked one of the cars up and realized I could no longer lose myself (note that phrase, 'lose myself'). Self-consciousness had crept in; a pall of embarrassment cast a shadow, like the Wicked Witch of the West, across my imaginary landscape. To paraphrase Picasso, it took me four years to be

able to draw a bit like Raphael but it would take me
a lifetime to regain anything like the joyful freedom
I felt with a box of Lego as a child. The sound a box
of Lego makes is the noise of a child's mind work-
ing, looking for the right piece. Shake it, and it's
almost creativity in aural form.

I wanted to be an artist because I loved drawing
when I was a young man but I'm not sure I really
knew what contemporary artists did. I hadn't been to
many art galleries or anything like that.

Recently a friend told me about a child
she encountered in an education programme she
was working on at the Whitechapel Art Gallery. At
the beginning of the project she asked the children,
'What do you think a contemporary artist does?'
And this particular child rather precociously put
her hand up and said, 'They sit around in
Starbucks and eat organic salad.' And I imagine
that is a pretty accurate assessment of many artists'
behaviour in the fashionable parts of a city. At the
end of the course, after they had spent some time
looking at what contemporary artists did, my friend
asked them, 'What do you now think a contempor-
ary artist does?' And the same child said, 'They
notice things.' And I thought, wow, that's a really
short, succinct definition of what an artist does.
My job is to notice things that other people
don't notice.

Alain de Botton, a writer about philosophy,
talks in his book *How Proust Can Change Your Life*

about people (literary tourists) looking for Combray, the fictional village where Proust set his master-work. And he said in many ways they've got it wrong because if they want to have a true homage to their hero, instead of looking at his world with their eyes, they should look at their own world with Proust's eyes.

An artist's job is to make new clichés.

But becoming an artist is not just a matter of having low impulse control or a burning, uncon-scious desire to express your humanity. At some point these urges need channelling. Going to art college is one of the few fixed rungs on an art-career ladder that feels more like a greasy pole. Of course people can become artists without going to art college – outsider artists are a fantastic example of this – but it's very difficult, if not impossible, to make a *career* as an artist if you haven't gone to college.

Of course many people would say art is a *non*-career, but in many ways, by defining ourselves as contemporary artists, we *are* saying, 'I'd quite like a career,' because the idea of an untutored genius seems quite quaint to me now, particularly in the West. Maybe there are still undiscovered geniuses in countries with more developing contemporary art scenes. Here in the West, though, the idea of a person suddenly springing up and being a brilliant contemporary artist never having gone to art school seems weird and a little bit naive.

The troubling, challenging thing is that deciding to attain an art education is to sign up for an advanced course in self-consciousness. Ironically, the very enemy of expression is also a tortuous necessity for anyone wanting to present their work to the art world. Two hundred years ago the painter John Constable said, 'These self-taught artists were taught by a very ignorant person.'

So when I said to my mother, 'I'm going to go to art college,' I got the usual reaction – as you would get from a working-class family – which was, 'It's not a proper job.' And in many ways, she was right.

On page thirty-one of the Department of Innovation and Skills Report, *The Returns of Higher Education 2011*, there's a rather stark graph. I feel quite bad bringing this up but we have to confront this situation. And that is, that compared to someone who's never been to university at all, the average art student will make just 6.3 per cent more money than that person. Although the gender difference is striking: women will make 11.7 per cent more; men 1 per cent less!

For an individual, it is self-evident that you do not go to art college if you want a guaranteed route to making money. I feel very heartened by the fact that so many young people are prepared to risk the debt and disappointment because they believe in art. Even though statistics are staring them in the face, telling them they're probably perpetuating

their poverty by doing it, they still go. I think that's lovely. I think that's a good thing.

I talked to a group of fine-art students recently and fundamentally I think their reasons for attending art school were very similar to mine. I heard the same uncertainty about who they were and what they wanted, the need to find themselves, the desire for freedom but also the desire to know what to do. Most of them still made 'things' but now with the added overwhelming problem of there being so many artists, galleries, possibilities, influences, techniques. One lad said whenever he had an idea he would google it and usually someone somewhere in the world had already done it.

The skip outside an art college is probably the repository of the ugliest objects on earth because they're not just ugly objects; they're ugly objects trying to be art. That skip is like a potpourri of broken dreams.

But that's how it should be! An art college is a place to experiment, a place of unique freedom. Often that freedom is the freedom to get it wrong. A large part of creativity is making mistakes and then noticing what's good about them. The art critic Martin Gayford wrote: 'Mistakes are as big a part of art as scholarship or truth. The Renaissance, for example, was based on a creative misunderstanding of classical antiquity. A great deal of nineteenth-century art derived from an incorrect assessment of the Middle Ages (and the

Renaissance). Picasso didn't comprehend
the first thing about the meaning of the African
sculptures he used as source material for *Les
Demoiselles d'Avignon.*'

Art history is a global version of that old
children's game Chinese whispers.

That's the fascinating, brilliant thing about it –
that people get it wrong – and that is a very, very
important part of being creative. Though when
faced with one's mistakes it can be a harsh lesson.

The essential thing one learns at art college is
difficult to condense. I think the most important
thing is being exposed to a certain sensibility, of
what it's like to be an artist. You're a trainee bohe-
mian and you're there with fellow travellers on this
journey, with facilities and tutors on hand. This
feeling of being among kindred spirits is vitally
important and one I find very moving. In this book
I've mocked the pomposities and joked about the
contradictions of the art world, but it's been like
teasing a dear friend because in reality, when I
joined the art world, it felt more like arriving in
Kansas than in Oz.

For young people who feel a bad fit with their
families or with wider society, to come within the
tolerant and accepting embrace of the art college
is a profound experience. The acceptance and
tolerance of their difference and their imagination
is an important thing. It's a subtle experience
being at art college because what you pick up is an

understanding, a bodily understanding, of what art and being an artist means at that moment.

It's also a great joy to learn a technique, because as soon as you learn it, you start thinking in it. When I learn a new technique my imaginative possibilities have expanded. Skills are really important to learn; the better you get at a skill, the more you have confidence and fluency. I like the idea of 'relaxed fluency' when you get into the zone and you've done your 10,000 hours and you've become really skilful. And it might be traditional skills, but it might be becoming skilful at negotiating an intervention in a municipal car park or gathering a group via Twitter.

At the end of it students emerge hoping to have found themselves unique. But, as the old saying goes, originality is for people with very short memories.

Of course, originality does exist and that shock of pleasure when you encounter it is one of the greatest things that anybody who's interested in art can experience. But the best artists can take quite a while to find their voice. An art career, after all, is a marathon, not a sprint.

I think one of the best descriptions of that process comes from Arno Minkkinen, a Finnish photographer. He came up with the Helsinki Bus Station Theory in 2004. He said that when you're leaving art college and you choose your style and what path in the art world you're going to take, it's like going to Helsinki bus station. There are

about twenty platforms and maybe ten buses leave from each platform, and you choose your bus and you get on the bus. And each stop is a year in your career. And after about three stops you get off and you walk into a gallery and you show them your work and the people look at it and they go, 'Oh, very nice, very nice. Reminds me a bit of Martin Parr though.' And you go, '*Uurrrgh!!* I'm not original, I'm not unique,' and you get really cross. So you get a taxi back to the bus station and you get on a different bus. And of course what happens is the same thing. What you need to do, says Arno Minkkinen, is stay on the fucking bus!

I think that's a marvellous description of the process. You know the buses are often on the same road for the first ten, twenty stops away from the bus station. Most artists are going to be influenced by something for the first ten years of our careers. Originality takes time. Carving out a career takes time. I didn't start making any money until I was thirty-eight, so I was well down the road before I got going.

(I left college with a 2.1. Nobody's ever asked. It was from Portsmouth Polytechnic. I was once interviewed by a radio journalist who rather mischievously asked if Portsmouth Poly was one of my female alter egos.)

I did what many people do when they leave college: I immediately applied for an MA. I was terrified of becoming just another artist in the

world. I applied to Chelsea for an MA and was
rejected because, and I quote, I was 'too much of
an artist and not enough of a student'.

This is probably the most difficult moment for a
young artist, leaving art college after all those years
of education. Suddenly it's just you and the world –
unprotected, undirected, and nowadays very much in
debt. It's not just an anxious time for the ex-student
but also for their parents, particularly if they have
little conception of the world their child is trying to
enter. I find it very poignant at degree shows when
I see parents up from the provinces looking bewil-
dered, trying to figure out what little Billy or Jilly has
been up to for three years and how on earth they are
going to make a living out of tying string round the
banisters or making warships out of cardboard
or videos of shadows.

I do think that you've got to take every opportu-
nity as a young artist or a designer. If somebody offers
you some little exhibition or a small part in a group
show or any tiny opportunity, you take it. You take
it because you never know. Every artist you know
who's successful will probably trace their career back
to some small event that was fairly insignificant,
but that event led them to meet someone, and so
on and so on. I had a show and then someone from a
museum bought one of my pieces very cheap. It got
put into the basement and was then discovered by a
curator when they did a show, and then I had a bigger
show, and so it began.

You also have to let yourself go to be creative and allow the ridiculous things to happen. One of my favourite quotes about creativity is from Robert Pirsig's *Zen and the Art of Motorcycle Maintenance*. He says ideas are like little furry creatures coming out of the undergrowth and you've got to be nice to the first one. Because that ridiculous idea you're having, suddenly that's your next ten years of really serious money-making work. People go, 'Oh my God, I've got to have an important idea for this exhibition.' I don't know if that's the right way to go about it. My technique, for example, is to drink beer and watch *X Factor* and get my felt pens out.

There is a boundary between being a student and becoming an artist. What this boundary is made of I am not sure. I think it is about identity. At some party someone will ask you what you do, and you will reply, 'I'm an artist.' You have to summon up the courage to say it. You may not have total confidence in that reply but you have crossed a boundary. You have started out on the hazardous path. At this point I may risk a dark sincerity. I feel it is a noble thing to be an artist. You're a pilgrim on the road to meaning. This is the central motif of my proudest achievement, which was my show at the British Museum, *The Tomb of the Unknown Craftsman*.

A conversation I had with the gallerist Sadie Coles many years ago has really stuck with me. I asked her, 'What do you look for when you're looking

for artists to bring into the gallery?' and she said, 'Commitment! Commitment to being an artist!'

Most of the successful artists I've met are very disciplined. They turn up on time, they put in the hours. That idea of us all being a bit chaotic and shaky, it's a myth. Artists are doers! They don't want to *be* artists, they want to *make art.* They enjoy making art. As I often say, this reminds me of a quote from Kierkegaard: 'In the old days, they loved wisdom. Nowadays they love the title "philosopher".'

But as my reputation grew in the 1980s and 1990s my earnings passed a point when I thought, 'I'm no longer in the realm of an appropriate wage for a skilled labourer.' Prices started to get into this airy-fairy whatever-anybody-will-pay-for-it arena. I had attained what I now dub 'Picasso Napkin syndrome', after the artist's fabled ability to pay for expensive meals just by drawing on the table linen. This is a version of the Midas touch: everything I doodle on or even just sign suddenly has financial value. This is a dangerous blessing for an artist and many have abused it. The temptation to churn out work in one's signature style to satisfy collector demand is very strong. Anything you sign is worth money! Artists like Andy Warhol literally did that. He would just sign a dollar bill and then suddenly it would be worth $100. Nowadays they are worth several thousand dollars!

Marcel Duchamp said, 'I could have made a hundred thousand ready-mades in ten years, easily,

and they would have all been fake. Abundant production can only result in mediocrity.'

By now, we've been chugging along in our art career for a while and we've somehow managed to keep that burning, precious, childlike glimmer of creativity burning, and people might think that I find being an artist easy, relaxing even. When I'm at a party, they ask me, 'What do you do?' and I say, 'Oh, I'm an artist.' And they go, 'It must be fun! What fun that must be – all that sculpting, pottery. Must be great fun!' And I go, 'Imagine this.' I say, 'Imagine this. You know, big museum, big museum. They've offered you an exhibition and there's a big room there – an open white room waiting for you to fill it. And in a year or two I've got to fill that with work and all the people are going to come and look at it, maybe thousands of people, and all the press are going to come and they'll want to write about it and talk about it, and then I've got to sell it. And the reaction of certain people – well, my income depends on it. And maybe the income of several other people, assistants and people working at the gallery. And then on top of that, I've got to create it with the carefree joy of a child! Does that sound like pure fun?' Art, it's a serious business!

One thing I'm glad about is that in kicking the can down the road of my career, somehow, I have indeed found myself.

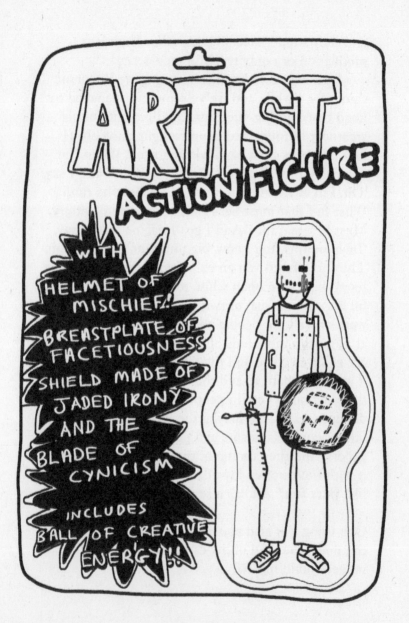

All artists carry within themselves, in their own way, an indistinct glowing ball of creative energy that they have to nurse through the assault course of becoming and growing as an artist. This is a tender cargo many artists, myself included, find it hard to talk about because we move around in the atmosphere of the art world, which is often very caustic – corrosive to such a delicate organism as one's creative drive. I protect my ball of creative energy. I protect it with a shield made of jaded irony, a helmet of mischief and a breastplate of facetiousness. And I wield my carefully crafted blade of cynicism. Because the part of myself that keeps me working year after year is too vulnerable to expose fully to the glare of the world.

I have a list of banned words that includes 'passionate', 'spiritual' and 'profound', all words it would be easy to reach for when describing the thing that keeps me making art. But the motivation is tender and it needs to be protected from clichés. (I have a particularly acute allergy to clichés because my mother ran off with the milkman.)

I came across this woman called Jennifer Yane. I don't know who she is, but she had this quote. It was, 'Art is spirituality in drag.'

I'm not going to say it, but it kind of describes what you're looking at when you look at art. It's a way of accessing spirituality almost by stealth – being tricked into all the colour and loveliness of the art. We look at it and suddenly we're having a

spiritual moment. But, like I say, I'm not allowed
to talk . . .

The metaphor that best describes what it's
like for my practice as an artist is that of a refuge,
a place inside my head where I can go on my own
and process the world and its complexities. It's an
inner shed in which I can lose myself.

The psychoanalyst Stephen Grosz writes of a
patient who was always talking about a house he
was planning and renovating in France and how
it was such an absorbing and enjoyable project,
thinking about how he was going to decorate it and
arrange the furniture, that he would always turn to
it in his mind when life got too much. It was very
relaxing for him to think about these marvellous
plans he had for his house in France. And then, at
the end of his course of psychotherapy, just as he
was leaving, he turned and he said, 'You do know,
don't you, Mr Grosz, that there is no house in
France? You do know that?'

I completely crack up at that because it really
echoes with me, that place where he goes: his
refuge where he's an artist.

Art Quality Gauge

instructions: hold card next to artwork and judge which location it would look most at home in then read off value.

TATE

ELTON JOHN'S LAWN

PROVINCIAL ARTS FESTIVAL

HIPSTER COFFEE BAR IN EAST LONDON

OLIGARCH'S ENTRANCE HALL

NATIONAL TRUST GIFT SHOP

ROUNDABOUT IN MILTON KEYNES

CAR BOOT SALE

IKEA

MUM'S BACK BEDROOM

The End

I HAVE HAD GREAT FUN THINKING ABOUT
these issues, which reflects the enormous fun
I have had over the decades being part of the art
world. In some ways this book is a love letter to
the art world. If I have been teasing (bullying) it
is because I know the art world can take it, in fact
it encourages it. None of my jibes stop the great art
being awesomely beautiful. I often count my bless-
ings that I am in a business where I am duty-bound
to seek out and look for beauty. I am also grateful

that I embarked on a career that, unlike music, literature or journalism, has not experienced so much economic and technological upheaval because of the internet. In fact it seems that, in the digital age, people are keener than ever to visit art galleries, to be in the presence of the actual unique object (and take a selfie in front of it, natch, to post on Twitter), and there are more artists, dealers, collectors and curators than ever.

A big part of my motivation for doing anything creative is to pass on the stimulation and pleasure I have had from observing the world and making the artefact. If I have in some way enhanced your next visit to a 'fine-art context' I am overjoyed. If you are still unsure how to react when confronted with a work of contemporary art, try a thought exercise I often fall back on. Imagine the conversation that would ensue if a punter brought the artwork, in a century or so, to be appraised on some twenty-second-century edition of *Antiques Roadshow*. Works for me!

And so here we are, at the end of the book. I've tried to answer some of the fundamental, obvious questions about the art world. I've not done this to expose the workings as some kind of trick, like ripping the curtain back on the Wizard of Oz, but because I think people might be intrigued by these things. I did it so that people like the Scarecrow and the Tin Man and the Lion might

enter the Emerald City of the art world a little smarter, a little braver and a little fonder.

Thank you for coming with me.

Thanks

Gwyneth Williams
Hugh Levinson
Jim Frank
Mohit Bakaya
Sue Lawley
Dr Sarah Thornton
Prof Charlie Gere
Mick Finch and fine art students
 at Central Saint Martin's
Karen Wright
Martin Gayford
Polly Robinson Gaer
Louisa Buck
Hans Ulrich Obrist
Martin Parr
Jaquie Drewe
Karolina Sutton
The Victoria Miro Gallery